W9-CGM-418

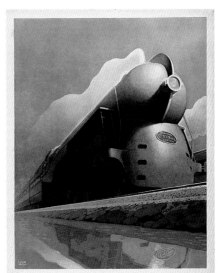

THE *New* 20TH CENTURY LIMITED

NEW YORK-*16 hours*-CHICAGO

NEW YORK CENTRAL SYSTEM

S T R E A M L I N E

STEVEN HELLER

AMERICAN ART DECO

S T R E A

CHRONICLE BOOKS

& LOUISE FILI

M L I N E

GRAPHIC DESIGN

SAN FRANCISCO

The authors are indebted to Suzette Ruys, our researcher, for the incredible time and effort put into locating the corporate archival material used in this volume. Our gratitude goes to Leah Lococo for her design and production assistance. Thanks also to Bill LeBlond, editor; Leslie Jonath, assistant editor; and Michael Carabetta, art director, at Chronicle Books, without whom this series of books would not be possible.

Additional thanks to the following representatives of institutions and archives for their generous loan of materials:
Philip F. Mooney, manager archives department, The Coca Cola Company; Anita Gross, registrar, and David Burnhauser, assistant registrar, The Wolfsonian Foundation, Miami, Florida; Barbara Meili, Kurt Thaler, Plakatsammlung, Museum für Gestaltung Zurich; Karri Dontanville, 30 Sixty Design Inc.; Henry Vizcarra, Wheatly Press; Luke J. Gilliland-Swetland, Research Center, Henry Ford Museum & Greenfield Village; Barbara D. Hall, Hagley Library Manuscript Collections, Pennsylvania Railroad Company Publications and Ephemera; Linda Hanrath, corporate archivist, W. Wrigley Jr. Company; David LeBeau, librarian, Chevron Services Company; Aimee G. Huntsha, Corporate Public Relations, Zenith Electronics Corporation; Dianne L. Brown and Amy E. Fischer, archivists, The Procter & Gamble Company; Judy Ashelin, External Affairs Archives, Shell Oil Company; James Fraser, librarian, Fairleigh Dickinson University; Karl Bernhard; Alex Steinweiss; Mary Edith Arnold, archivist, Motorola Inc. Corporate Archives; Robert B. Finney, historian, Phillips Petroleum Co. Corporate Archives; Sharman Robertson, archivist, Hallmark Cards, Inc.; Annette Brewer, The Goodyear Tire & Rubber Company; Don Snoddy, museum director, Union Pacific Railroad Company; The Cooper Hewitt Museum of Design; Barbara Haase, Special Collections and Archives, George Mason University; The New York Public Library, Performing Arts Library.

CREDITS

Plakatsammlung, Museum für Gestaltung Zurich: 1, 73 (top right); The Wolfsonian Foundation: 62, 71, 72, 75, 76; Henry Ford Museum & Greenfield Village: 41 (left), 52 (top), 59 (right), 82, 83, 86; The Procter & Gamble Company: 39; 30 Sixty Design Inc.: 42, 43, 88, 91, 98, 99, 110, 111; W. Wrigley Jr. Company: 51 (top); Karl Bernhard: 57; Motorola Inc.: 68, 69; Chevron Services Company: 78; Hagley Library Manuscript Collections: 81; Alex Steinweiss: 97; George Mason University: 108, 109; The Cooper Hewitt Museum of Design: 129 (right)

Research assistance by Suzette Ruys. Book design by Louise Fili and Leah Lococo.

Copyright © 1995 by Steven Heller and Louise Fili. All rights reserved. No part of this book may be reproduced in any form without written permission from the publisher. Library of Congress Cataloging-in-Publication Data: Heller, Steven. Streamline : American art deco graphic design / by Steven Heller and Louise Fili. p. cm. Includes index. ISBN 0-8118-0662-6 1. Commercial art—United States. 2. Decoration and ornament United States—Art deco. I. Fili, Louise. II. Title. NC998.5.A1H46 1995 741.6'0973'09042—dc20 94-13128 CIP Printed in Hong Kong. Distributed in Canada by Raincoast Books, 8680 Cambie Street, Vancouver, B.C. V6P 6M9 10 9 8 7 6 5 4 3 2 Chronicle Books, 85 Second Street, San Francisco, CA 94105 Web Site: www.chronbooks.com

Streamline was a distinctly American design style forged in the crucible of the social and economic turmoil of the 20s and 30s. Overproduction for inactive markets demanded radical measures and forced business into an unprecedented alliance with a new professional known as the designer. In an effort to stimulate consumption these white knights of industry launched a crusade against outmoded industrial output that resulted in the application of new futuristic veneers that brought out the inherent machine-made attributes of products and commodities. Influenced by Modern art, which to a certain degree was inspired by the machine itself, the industrial designer was not like the nineteenth-century decorator, an apologist for or rebel against mass production, but rather a visionary who understood that art should be of its time and products should represent the era in which they are produced.

Whereas Victorian and Art Nouveau styles of the late nineteenth and early twentieth centuries hid evidence of the machine under faux naturalism, Streamline's aerodynamics symbolized the mechanized tempo of daily life. By 1938 Streamlining was such a widespread practice that Sheldon and Martha Candler Cheney wrote in their seminal analysis of

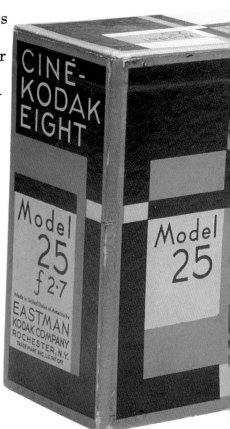

American industrial design, *Art and the Machine* (Whittlesey House, 1939), that "Everywhere, there is . . . merchandise distinguished by the beauty that is peculiarly a product of artist and machine working together."

Industrial products were not, however, the first to receive a Machine Age makeover. In the early 1920s European Modernism, which was practiced at the Bauhaus and through affiliated schools and movements and proposed the objectification of everyday products, was introduced to the American consumer primarily through magazine advertising. Yet the term *modernistic,* connoting the commercialization of this radical design language, is a more accurate way to describe the new advertising trends. Modernistic design was ersatz modernism. Although it employed Modern characteristics, such as rectilinear rather than curvilinear form common to Art Nouveau, it was not a total rejection of functionless ornament but rather a compromise between purism and bourgeois luxury. Aspects of Cubist and Futurist painting were adopted as ornamental motifs that imbued new life in otherwise traditional layouts, and eventually modernistic art was seamlessly wed to the Modern typographic principles that stressed asymmetry

KODAK
CAMERA PACKAGE, C. 1931
DESIGNER: WALTER DORWIN TEAGUE

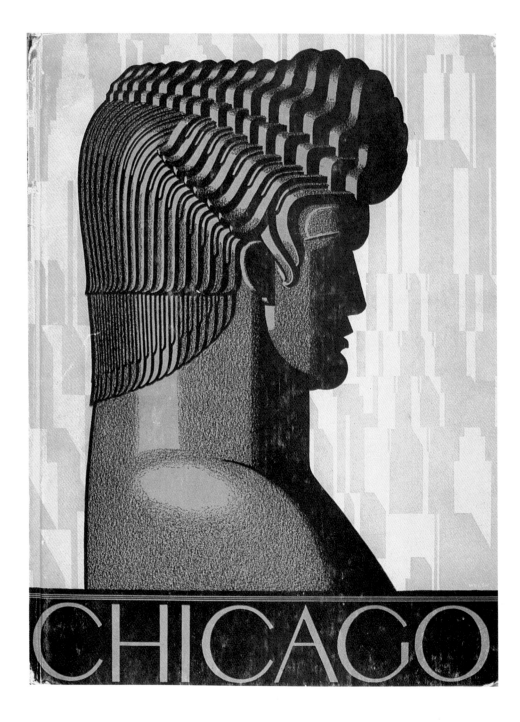

and sans serif letterforms over central axis classicism. Geometric patterns and shapes, including ziggurats and lightning bolts borrowed from antiquity, were streamlined into emblematic icons and glyphs that came to personify modernity.

Modernistic graphics framed and "dressed" otherwise quaint and timeworn products. Yet, in what became a typically American marketing ploy, it was the advertising and packaging, not the product itself, that was smartly styled. In the early 1920s the practice called "styling" had not yet been adopted for industrial wares. And despite an alarming downturn in the sale of new merchandise beginning in the mid-1920s, business was not yet convinced that the blame for sluggish consumerism should be placed on poorly designed or old-fashioned-looking products. Businessmen reasoned that advertising was the panacea; great campaigns would stimulate consumer enthusiasm. Marketing strategies were developed to present the illusion of progress using typography and imagery that was seductively progressive, or what the industrial designer Raymond Lowey referred to as MAYA, "most advanced yet acceptable."

The widespread availability of color printing spurred advertising agencies to change their tired design conventions. Merely increasing the visibility of a product was no longer enough; it needed to be imbued with an aura that spoke more to image than utility. In addition to advertising, a product's packaging was as important as its function.

So beginning in the 1920s advertising strategists turned from promoting *things* to selling *ideas*. "More and more art directors have striven to express . . . not so much the picture of a motor car as motion, action, transportation," exclaimed Earnest Elmo Calkins, the president of Calkins and Holden Inc., a leading New York advertising agency, who was writing in *Modern Publicity* (1930). "Not so much a vanity product as lure, charm, fascination; not so much a breakfast food as gustatory delight, vigor, health, vitamins, sunlight." This was accomplished not through romantic realism but through lush abstraction.

America did not invent abstract advertising. It started in Europe at the turn of the century and was founded in symbolic (often productless) representations. In the early 1920s "advertising engineers," as some utopian graphic designers referred to themselves in Russia, Germany, Holland, Czechoslovakia, and Hungary, practiced progressive approaches to advertising and posters that at once promoted products *and* demolished the barriers between fine and applied art. By 1925, when the first exhibit to promote modernistic design, the *Internationale des Arts Décoratifs et Industriels Modernes*, opened along the banks of the Seine, aspects of styleless, orthodox Modernism had already been adopted to create a more luxurious decorative commercial style called Art Moderne.

When Americans were introduced to European Modern art at the 1913 Armory Show in New York, the style was greeted with predictable skepticism and ridicule, but

after American trendsetters returned from Paris with the latest styles and then applied modernistic design to advertising, packaging, and window display the public became enthusiastically accepting. This was not because the masses developed an overnight appreciation for higher levels of culture but rather that over time the inevitable shock of the new wore off and the transformation of certain avant-gardisms into marketing tropes kicked in. In an essay titled "Modern Layouts Must Sell Rather Than Startle" (*Advertising Arts*, 1930), Frank H. Young explained the trend that he called "gone modern." "The layout man has grasped the advantages of the use of modern art in the creation of his arrangements to arrest the reader's eye impressively and to robe the advertisement in a refreshing new dress."

With Pavlovian predictability consumers began to associate modernistic design with the idea of *new and improved*. Earnest Elmo Calkins wrote in *Advertising Arts* (1930), "Modernism, or what is conceived to be modernism, has profoundly influenced American advertising design in both the pictorial treatment and the typography." As one of the most influential advertising executives of the age, Calkins was a pragmatist not a utopian, for he was not interested in Modernism as a force for social change, like the Europeans, but used it as an alternative to the commonplace, and therefore a means to turn the tide of consumer indifference. He promoted "consumption engineering" and

proselytized the business community to accept "styling" as a marketing strategy. He asserted that this was the key ingredient of the marketing scheme called "obsoletism." "The styling of manufactured goods, which has become such a widespread movement in this country," he wrote, "is a by-product of improved advertising design. The styling of goods is an effort to introduce color, design and smartness in the goods that for years have been accepted in their stodgy, commonplace dress. The purpose is to make the customer discontented with his old type of fountain pen, kitchen utensil, bathroom or motor car, because it is old-fashioned, out-of-date. . . . We no longer wait for things to wear out. We displace them with others that are not more efficient but more attractive."

Obsoletism became the ultimate capitalist tool and the engine that propelled the Streamline movement in the 1930s. Artists for Industry, as the early industrial designers called themselves, believed it was their role to fulfill advertising's promises by designing and developing products that not only looked new but included substantial mechanical improvements. While the term *Streamline* suggests a modicum of artifice, the application of aerodynamic and other engineering principles to products and machinery significantly increased their efficiency. The paradigms of Streamline design are monuments of Machine Age retooling. Although not as pure in its rejection of ornament as the Bauhaus adherents would have preferred, the Streamline ethos was nevertheless resolutely

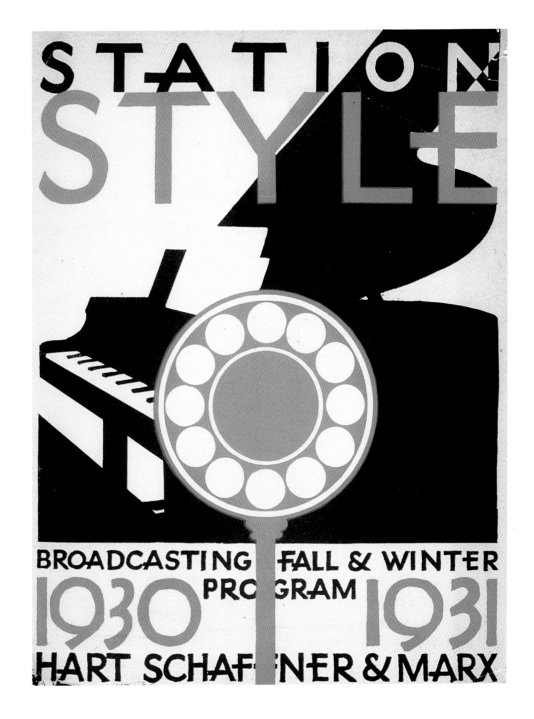

progressive within the limits of the commercial arena. Its primary exponents were dedicated to reviving the American economy and fervently believed that good design would do the job. Style was not arbitrarily affixed to products but was added to distinguish old from new and to encourage national pride through a distinctly American aesthetic.

Yet forced obsolescence also encouraged excess, and the modernistic aesthetic was often carried to extremes. "It must be admitted . . . ," wrote type historian and proponent of modernistic design Douglas C. McMurtrie in *Modern Typography and Layout* (Eyncourt Press, 1929), "that there have been numerous excesses and absurdities . . . in the use of type, masquerading under the guise of modernism." And Frank H. Young noted in his paean to contemporary design, *Modern Advertising Art* (Covici, Friede Inc., 1930), "In some instances enthusiasm for modernism has overshadowed good judgment and the all-important selling message is completely destroyed. Unless sound judgment is employed with a good reason for the particular disposal of each element and the use of modernistic devices, failure of the purpose of the advertisement is sure to result. The crash of a freakish layout will call attention only to itself and the reader will fail to react favorably to the message, if indeed he gets it at all." Both referred to superfluous ornamental ziggurats, lightning bolts, and heroic Grecian body parts that commonly appeared in countless printed pieces. McMurtrie cautioned that the modern style should be "used

with restraint, and with due consideration of the audience it addresses." While Young added, "In a good modern layout the principles of all good layout still prevail . . . cohesion, legibility, movement, emphasis, simplicity and continuity."

The modernistic graphic style was so popular, and so easy to achieve owing to a plethora of models and templates presented through commercial arts manuals and advertising trade magazines, that a certain blind adherence was natural and resulted in pale imitations of exemplary work. Predictably, Streamline graphic design developed into a lexicon of stylish, futuristic mannerisms that became so overused that it was no longer helpful as a distinctive marketing tool. Nevertheless it was not redundancy that killed off the style but the outbreak of World War II. Not only were alluring bourgeois graphics unnecessary in an austere wartime economy but many of the products that required modernistic promotion ceased being produced for the duration. Modernistic styling, which was already on its way out by the opening of the 1939 New York World's Fair (which became both the zenith and nadir of Streamline design), was suspended in favor of functional products, simplified packages, and unambiguous graphics that helped promote the war effort. By 1942 Streamline was over, but it is celebrated (indeed revived) today, in spite of its excesses, as a distinctly American design aesthetic that profoundly influenced the look of popular culture.

The conflict between tradition and modernity is best illustrated by the point-of-purchase advertisement for shoe polish on this page: the women's clothes are contemporary, the decorative graphics are stylish, but the package in which the product is sold is dressed in nineteenth-century garb. This essential stylistic contradiction was commonplace in consumer culture, and the critics argued that it contributed to malaise in the marketplace. In an effort to discourage consumer apathy Earnest Elmo Calkins campaigned for the redesign of packages to reflect the times in which they were produced. In this way an American consumer style would emerge.

There was no better field to test style than the fashion industry. Clothing was at once the most utilitarian and image-based commodity. Even prior to Calkins's mandate, styling was so endemic to fashion that clothing manufacturers knew utility alone was not enough to

FOR
SPORT AND
DRESS SHOES

Be Sure You Say "AN

bolster sales. By the turn of the century mail-order catalogs, press advertisements, and magazines promoted new fashions through quaint, though alluring, renderings that were sedate by modernistic standards. With the onset of America's Jazz Age of the early 1920s, clothing was one of the first commodities to be influenced by commercial modernism. Sleek dresses, tapered suits, and cloche hats bearing moderne prints and patterns replaced the frills of the past. To promote these flights of fancy, fashion periodicals such as *Vogue* and *Harper's Bazaar* became clarions of modernity that employed artists to represent, indeed mythologize, fashions through cubistic, futuristic, and otherwise chic renderings. Department store windows, catalogs, shopping bags, and clothing boxes introduced the style to the masses. By embracing the moderne sensibility average citizens became advertisements for the modernistic style.

ANGELUS

GLOSSY WHITE SHOE DRESSING
for
Cleaning whitening and shining White Kid

ANGELUS SHOE POLISH CO.
Los Angeles, Calif.
U.S.A.

THE
PERFECT
WHITE SHOE DRESSING

LUS" White Shoe Dressing

ANGELUS
POINT-OF-PURCHASE
DISPLAY, C. 1932
DESIGNER UNKNOWN

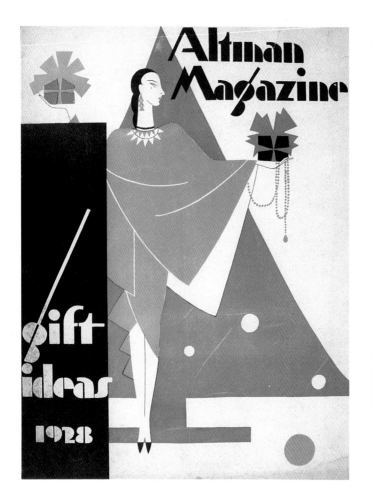

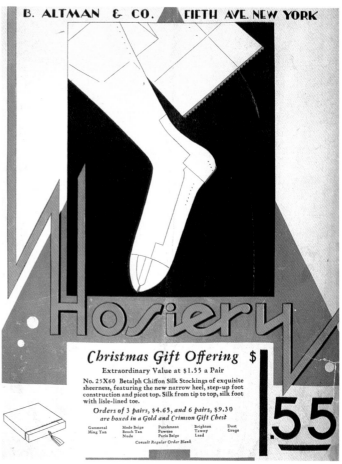

ALTMAN MAGAZINE

CATALOG COVER, 1928

DESIGNER UNKNOWN

HOSIERY

ADVERTISEMENT, 1928

DESIGNER UNKNOWN

MACY'S

PROMOTIONAL POSTER, 1929

DESIGNER: LEO RACKOW

macy's

has everything

......for......

......school......

we're on 34th street & broadway

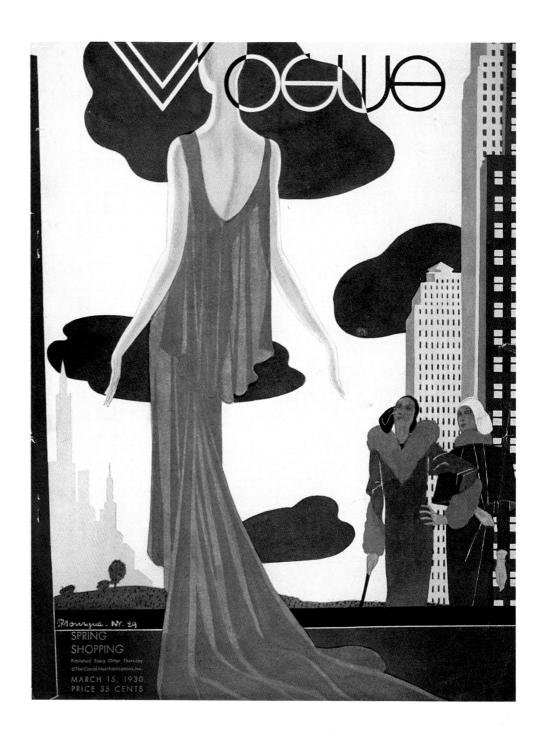

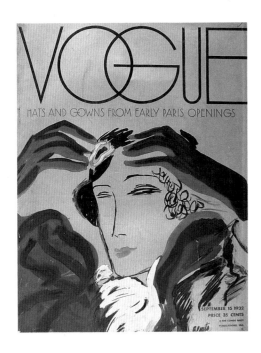

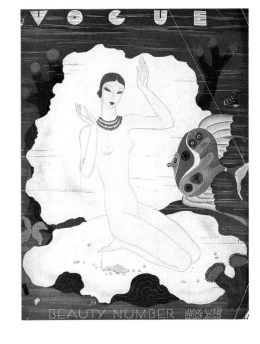

VOGUE

MAGAZINE COVER, 1932

ILLUSTRATOR: EDUARDO BENITO

VOGUE

MAGAZINE COVER, 1933

ILLUSTRATOR UNKNOWN

VOGUE

MAGAZINE COVER, 1939

ILLUSTRATOR: WITOLD GORDON

VOGUE

MAGAZINE COVER, 1930

DESIGNER: ZEGLINGER

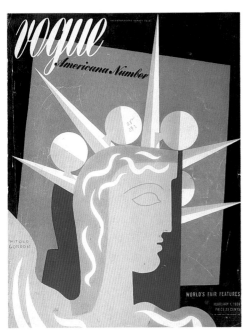

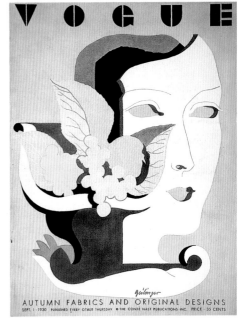

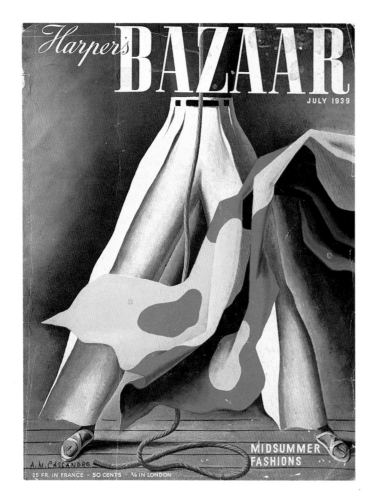

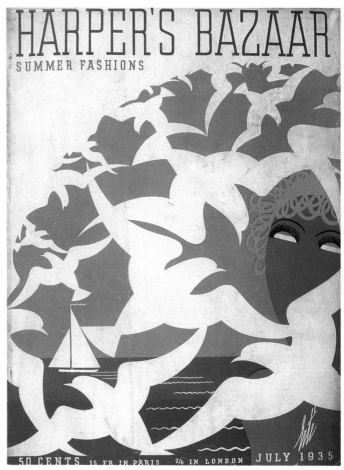

HARPER'S BAZAAR

MAGAZINE COVER, 1939

DESIGNER: A. M. CASSANDRE

HARPER'S BAZAAR

MAGAZINE COVER, 1935

DESIGNER: ERTÉ

HARPER'S BAZAAR

MAGAZINE COVER, 1938

DESIGNER: A. M. CASSANDRE

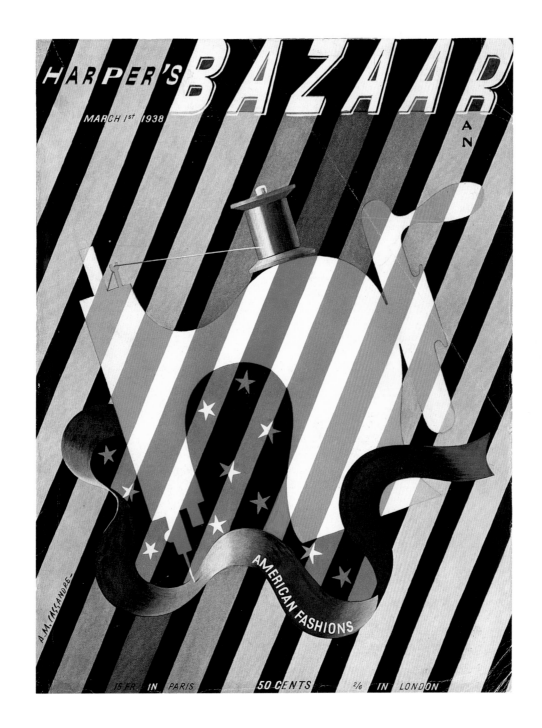

23

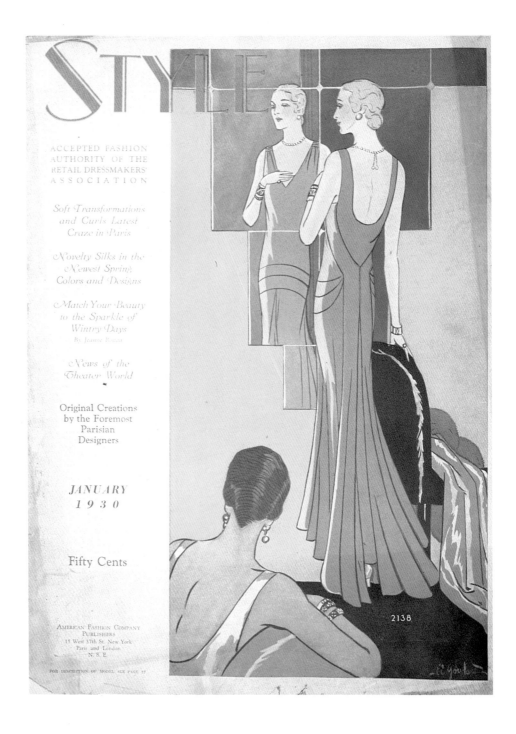

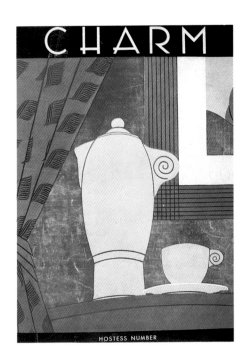

CHARM

MAGAZINE COVER, 1931

DESIGNER: AUGUST R. SCHNITZLER

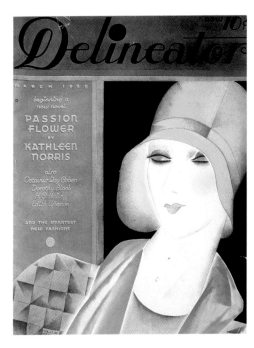

DELINEATOR

MAGAZINE COVER, 1930

DESIGNER: HELEN DRYDEN

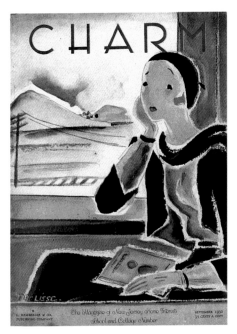

CHARM

MAGAZINE COVER, 1930

DESIGNER: McLISSIC

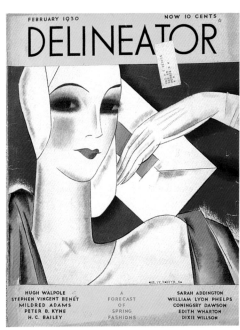

DELINEATOR

MAGAZINE COVER, 1929

DESIGNER: HELEN DRYDEN

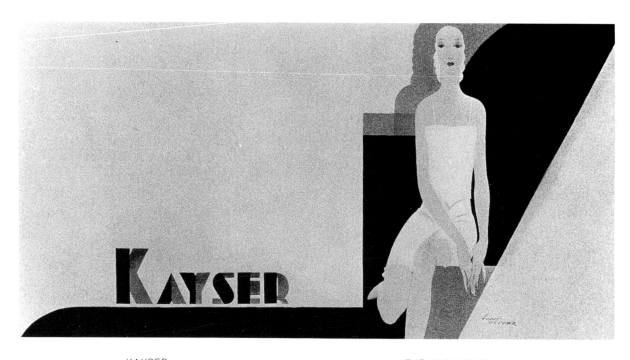

KAYSER

BILLBOARD, JULIUS KAYSER, INC., 1930

DESIGNER: JUAN OLIVER

THE KNOX SHOP

BILLBOARD, KNOX HATS, C. 1930

DESIGNER: ART DEPARTMENT/FOSTER & KLEISER CO.

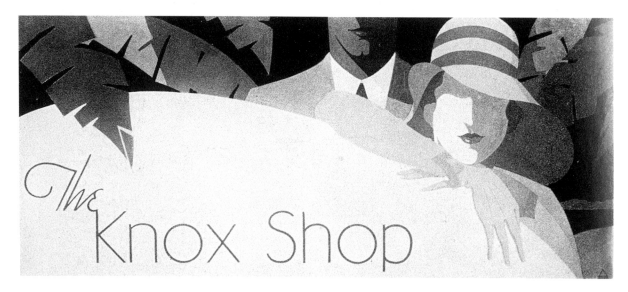

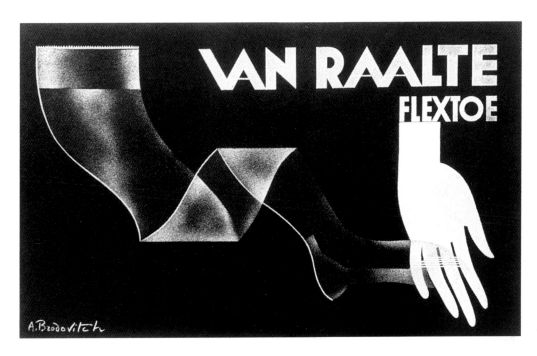

VAN RAALTE

BILLBOARDS, 1930; DESIGNER: ALEXEY BRODOVITCH

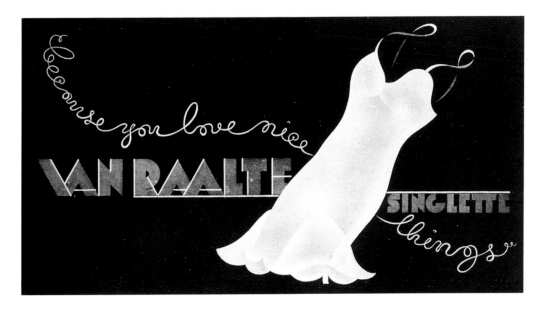

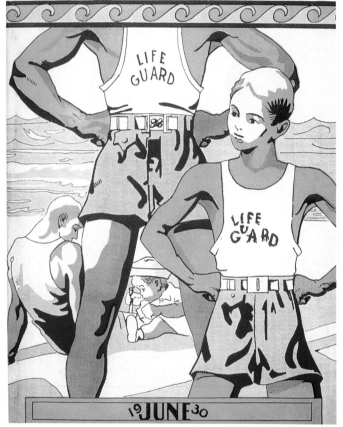

THE BOYS BUYER

TRADE MAGAZINE COVER, 1930

DESIGNER: D.H.

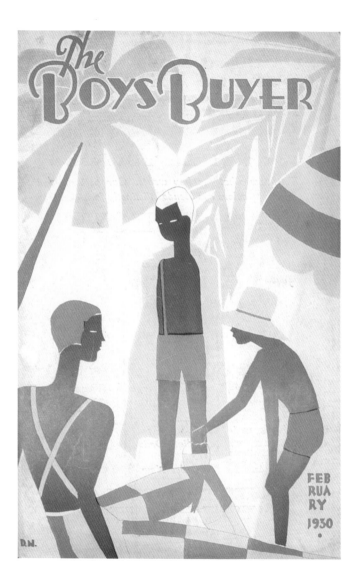

THE BOYS BUYER

TRADE MAGAZINE COVER, 1930

DESIGNER: D.H.

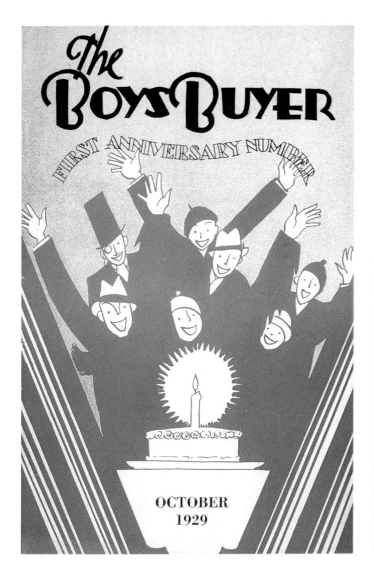

THE BOYS BUYER

TRADE MAGAZINE COVER, 1929

DESIGNER: D.H.

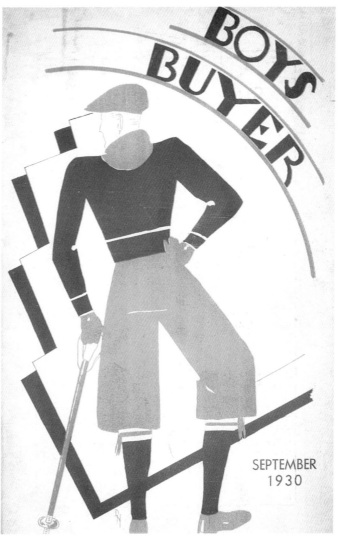

THE BOYS BUYER

TRADE MAGAZINE COVER, 1930

DESIGNER: D.H.

MARLBORO

SHIRT ADVERTISEMENT, 1938

DESIGNER: LUCIAN BERNHARD

ECK-SELL

SUSPENDERS PACKAGE, C. 1928

DESIGNER UNKNOWN

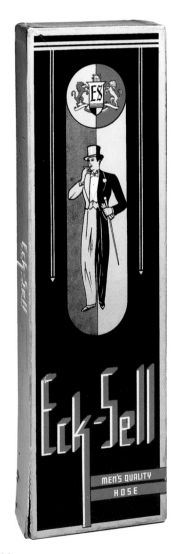

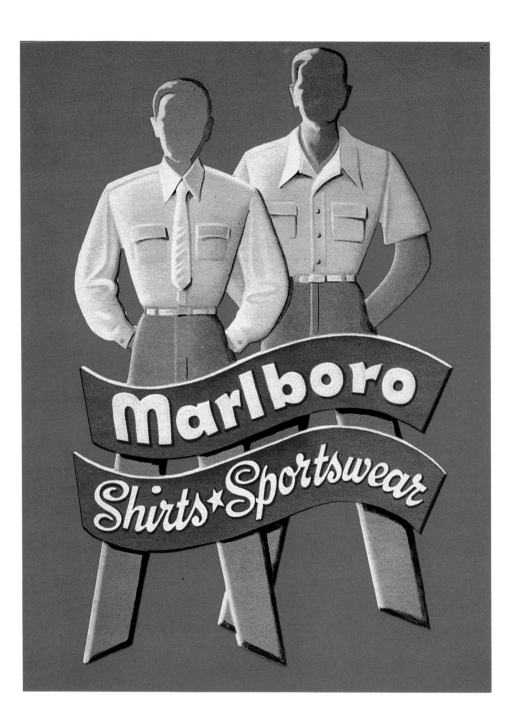

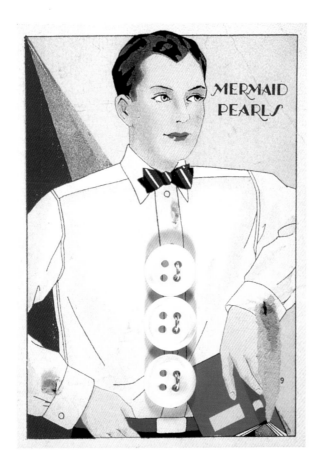

MERMAID PEARLS

BUTTON CARD, C. 1928

DESIGNER UNKNOWN

ARROW COLLARS

COLLAR PACKAGE, C. 1925

DESIGNER UNKNOWN

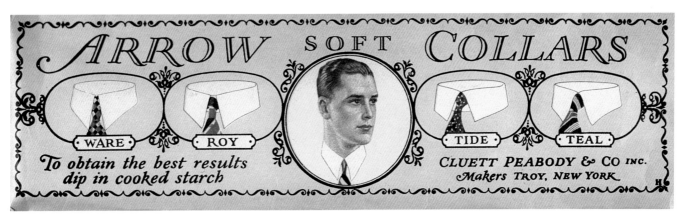

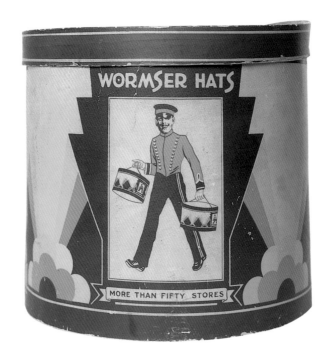

WORMSER HATS

HAT BOX, 1932

DESIGNER UNKNOWN

STETSON STRATOLINER

HAT BOX, 1938

DESIGNER UNKNOWN

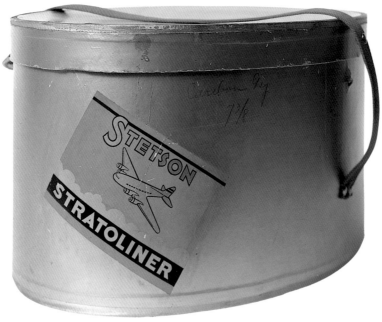

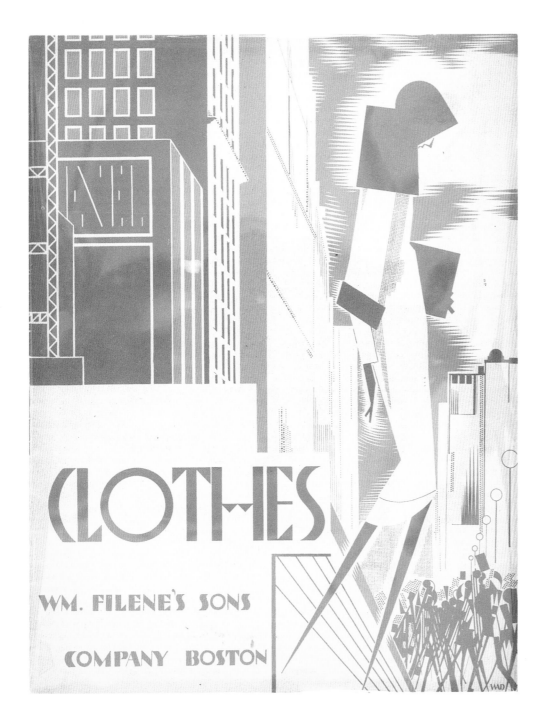

CLOTHES
FILENE'S CATALOG, C. 1928
DESIGNER:
WILLIAM ADDISON DWIGGINS

From the turn of the century to the 1920s most contemporary furnishings and accessories were modeled on, indeed mimicked, past styles. Modern advertisers therefore targeted the home as a battleground for the consumers' hearts, minds, and dollars. So using all the stylistic weaponry at their command advertising agencies applied modernistic aesthetics to a wide range of housewares and household products, even where such styling was really irrelevant. The advertising triptych for paint shown on this page, which exploits a genre of modernistic design influenced by ancient Egyptian styles, suggests that with this remarkable product even the average American woman can personally (and inexpensively) modernize a home.

Realizing that the stylistic trend was a viable marketing tool, magazine publishers changed the look of many time-honored domestic periodicals to conform to and further

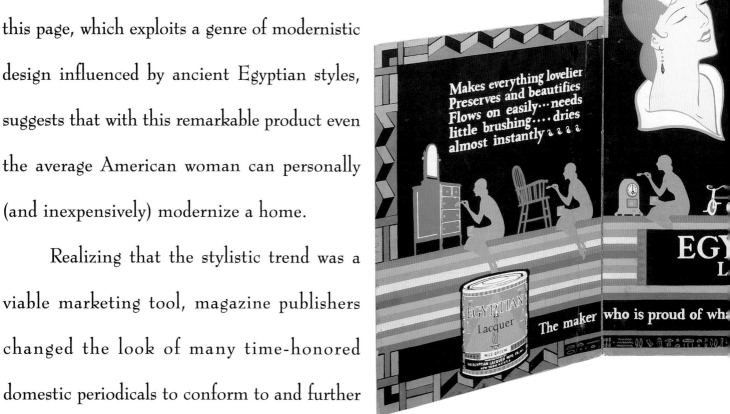

promote modernity. The new aesthetic was introduced slowly at first by adding a hint of contemporary color and pattern to traditional styles. Moderne graphics were a portent of what was to come. And come it did in all kinds of shapes, sizes, and materials. Domestic packages for commodities such as detergent soap, household cleanser, and furniture polish were dressed in smart graphics that appealed less to the product's utility than its contemporary image. When encouraged by stylish advertising, what consumer would choose a timeworn brand to a modernistic icon? To be anything less than moderne would be déclassé. Once modernity took off it became the code for progress, if not always for comfort. The battle was soon won on the home front. With its modernistic appointments a house became a citadel of modernism, and soon other contemporary buying habits fell into place.

EGYPTIAN LACQUER
POINT-OF-PURCHASE
DISPLAY, 1933
DESIGNER UNKNOWN

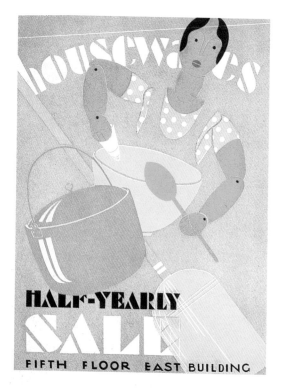

HOUSEWARES

POSTER, 1931

DESIGNER UNKNOWN

MACY'S INTRODUCES COLOR

POSTER, 1929

DESIGNER: LEO RACKOW

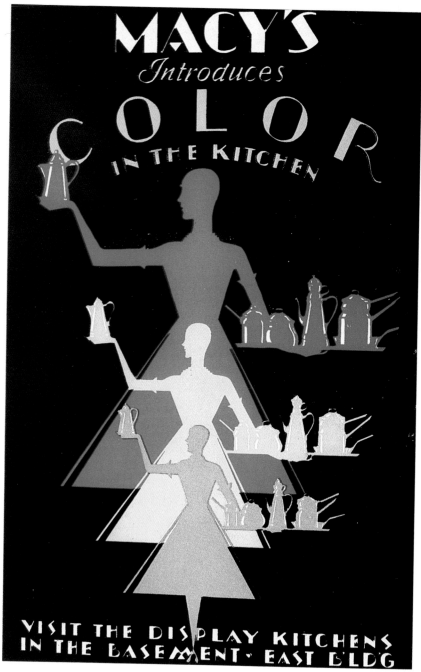

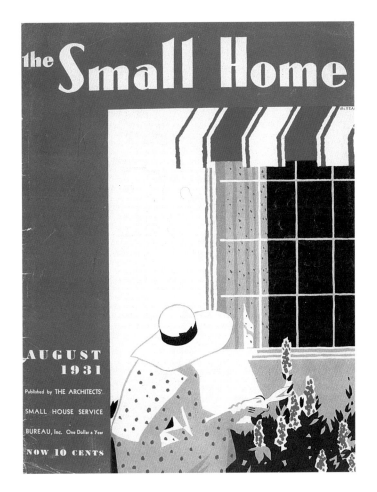

THE SMALL HOME

MAGAZINE COVER, 1931

DESIGNER: McNEAR

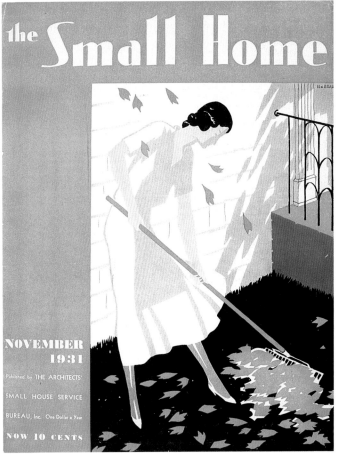

THE SMALL HOME

MAGAZINE COVER, 1931

DESIGNER: McNEAR

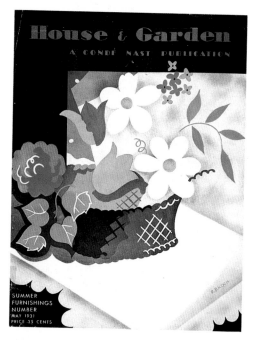

HOUSE & GARDEN

MAGAZINE COVER, 1931

DESIGNER: R.B. KOCH

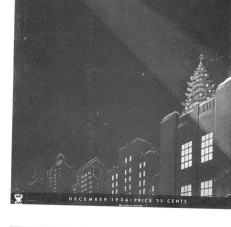

HOUSE BEAUTIFUL

MAGAZINE COVER, 1934

DESIGNER UNKNOWN

HOUSE & GARDEN

MAGAZINE COVER, 1921

DESIGNER: H. GEORGE BRANDT

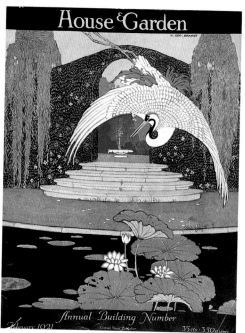

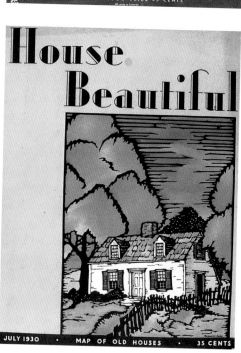

HOUSE BEAUTIFUL

MAGAZINE COVER, 1930

DESIGNER: MARGUERITE KUMM

FIRESIDE GIFTS

CATALOG COVER, 1930

DESIGNER UNKNOWN

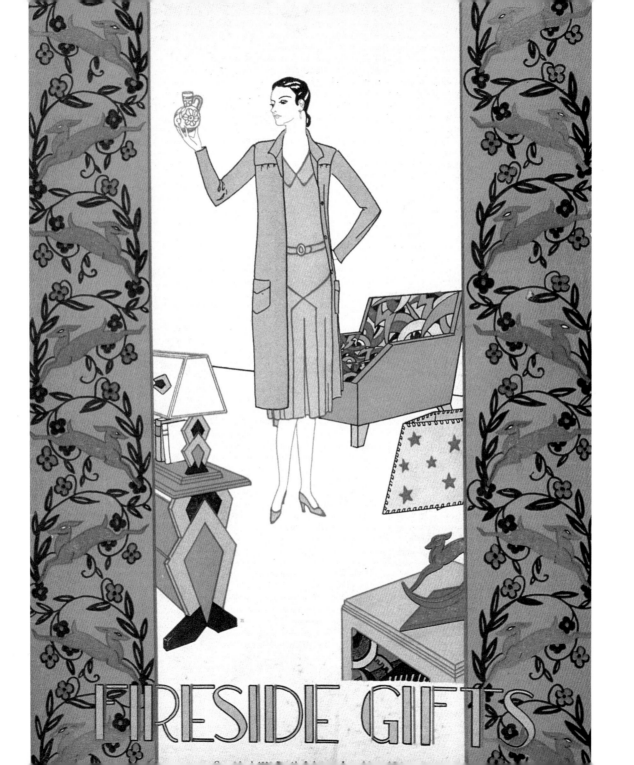

FIRESIDE GIFTS

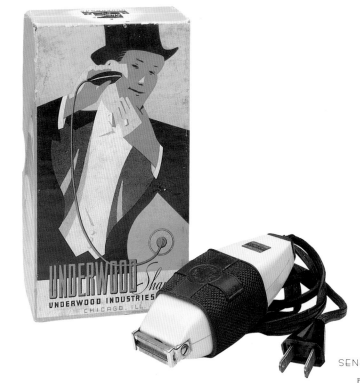

UNDERWOOD SHAVER

PACKAGE, C. 1935

DESIGNER UNKNOWN

SENECA BOUDOIR IRON

PACKAGE, C. 1935

DESIGNER UNKNOWN

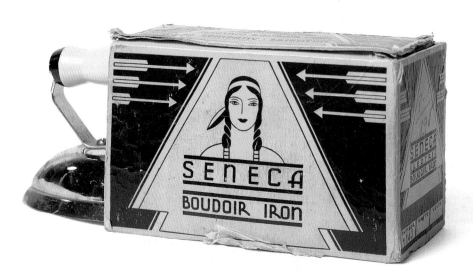

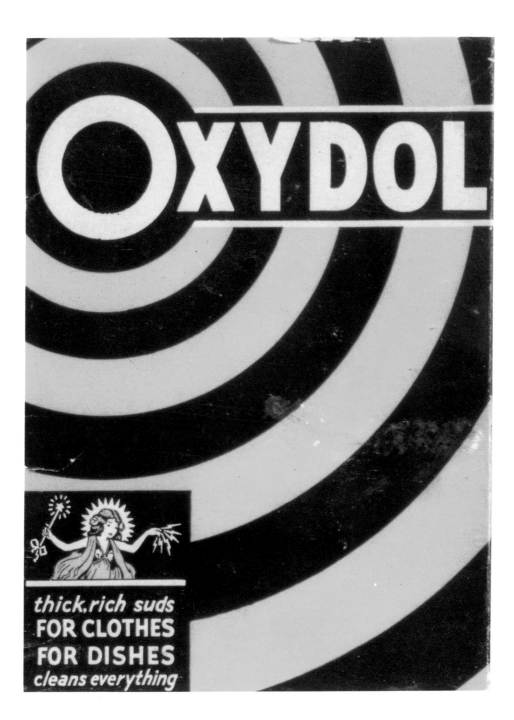

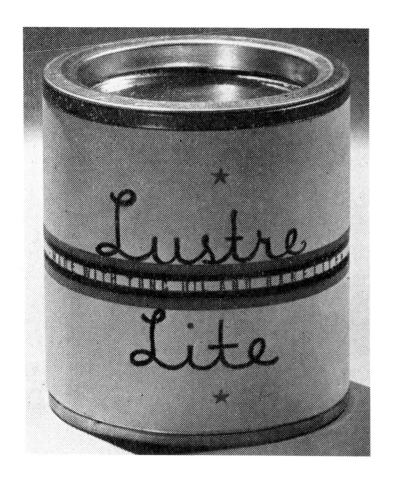

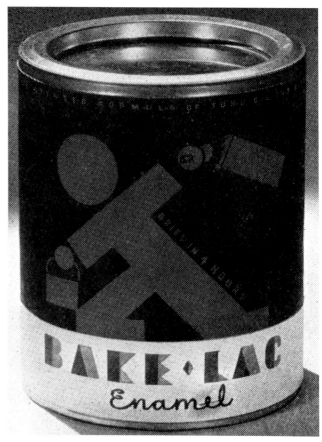

LUSTRE LITE

POLISH PACKAGE, C. 1937

DESIGNER UNKNOWN

BAKE LAC ENAMEL

PACKAGE, C. 1936

DESIGNER UNKNOWN

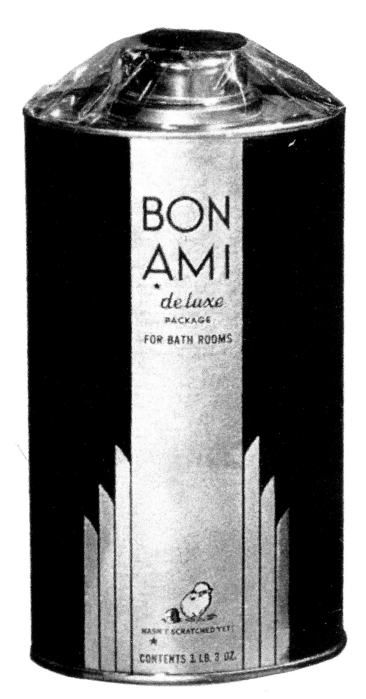

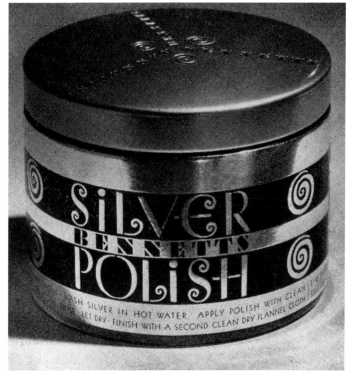

BENNETTS

SILVER POLISH PACKAGE, C.1936

DESIGNER: GUSTAV JENSEN

BON AMI

CLEANSER PACKAGE, 1931

DESIGNER UNKNOWN

MORE WOMEN DIE OF CANCER

HEALTH POSTER (WPA), C. 1936

DESIGNER: ALEX KALLENBERG

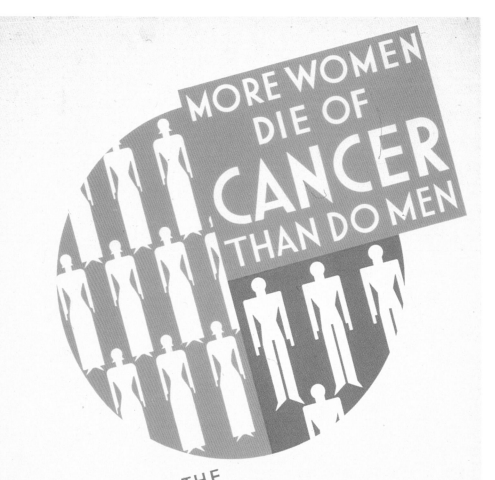

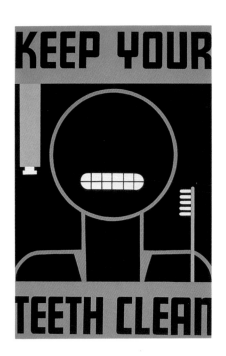

KEEP YOUR TEETH CLEAN

HEALTH POSTER (WPA), C. 1935

DESIGNER UNKNOWN

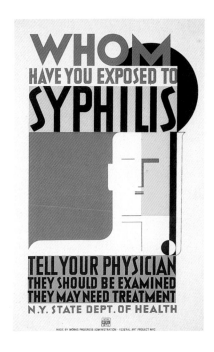

WHOM HAVE YOU EXPOSED TO SYPHILIS

HEALTH POSTER (WPA), C. 1935

DESIGNER: CHARLES VERCHURREN

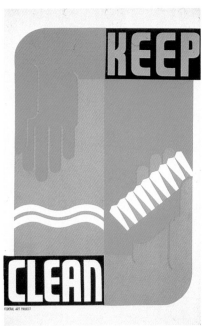

KEEP CLEAN

HEALTH POSTER (WPA), C. 1935

DESIGNER UNKNOWN

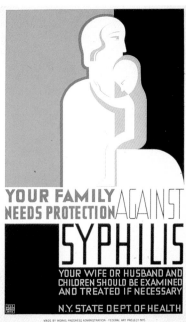

PROTECTION AGAINST SYPHILIS

HEALTH POSTER (WPA), C. 1935

DESIGNER: CHARLES VERCHURREN

Despite the European Moderns' desire for a universal design vocabulary that would somehow unify the chaotic industrial world, they never bargained for, nor would they have been in favor of, "consumption engineering" as it was practiced in the United States. While its creator, Earnest Elmo Calkins, fervently believed that engineered modernity would rescue the American economy from the Depression, it was also the foundation on which waste was absolved in the name of bolstered consumerism. Modernistic graphic design was therefore a dubious force for change. Although products with moderne veneers attracted consumer attention, many of the products were actually no better or worse than comparable brands that were not so dressed. In the name of styling, many old and new products, including food and foodstuffs, were contorted to fit the prevailing fashion.

Once it established a foothold in the home, moderne graphics moved directly to the kitchen. Progress attached itself to packages for beverages, such as milk and coffee,

prepackaged foods, and especially candies. Modernism was targeted at women in the home, and their image in most modernistic advertising representations was fashionably streamlined to eschew any hint of drudgery associated with homemaking. Through the suggestion of luxurious modernity, modernistic design implied that women's work was made easy by the advances that American industry had bestowed upon them. The primary reason for designing even food and drink packages in "modern dress," as the industrial designer Egmont Arens called the trend in *Advertising Arts* (1930), was not, however, to make the product more efficient but merely to lure the female consumer away from one brand in favor of another. Given the ethos of style obsolescence that Calkins promoted and that American business was happy to follow, the war to make the world safe for consumption was primarily fought at the food market.

NECCO CANDIES

JELLY DROPS BOX, C. 1933

DESIGNER UNKNOWN

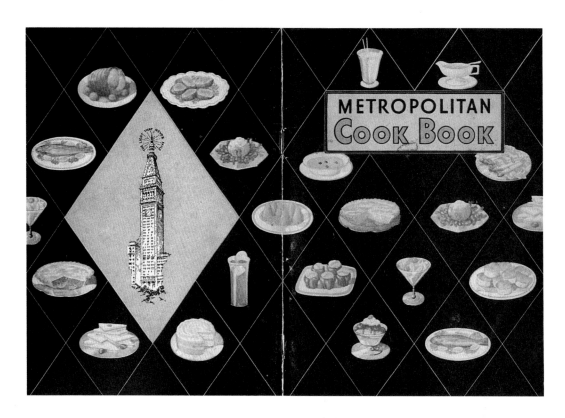

METROPOLITAN COOK BOOK

RECIPE BOOKLET, 1931

DESIGNER UNKNOWN

FOR MAKING GOOD THINGS TO EAT

RECIPE BOOKLET, 1931

DESIGNER UNKNOWN

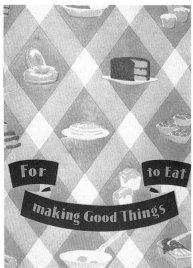

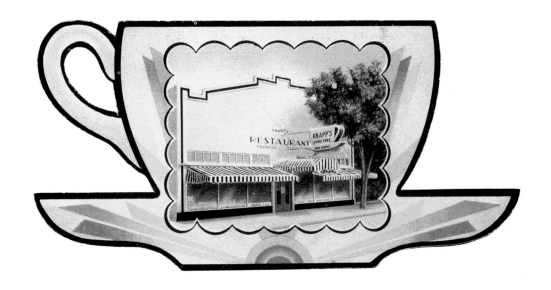

KNAPP'S GOOD FOOD

ADVERTISING BROCHURE, C. 1930

DESIGNER UNKNOWN

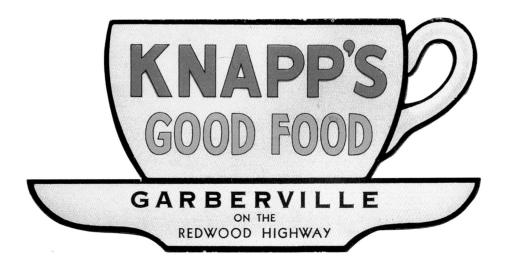

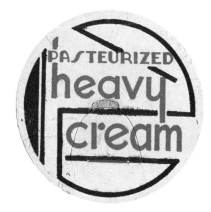

HEAVY CREAM

BOTTLE CAP, C. 1939

DESIGNER UNKNOWN

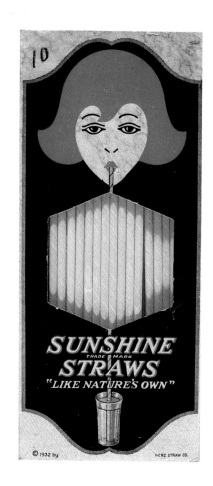

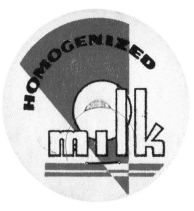

MILK

BOTTLE CAP, C. 1939

DESIGNER UNKNOWN

WASH DAILY

BOTTLE CAP, C. 1939

DESIGNER UNKNOWN

SUNSHINE DAIRY

BOTTLE CAP, C. 1939

DESIGNER UNKNOWN

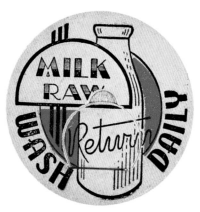

SUNSHINE STRAWS

PACKAGE, 1934

DESIGNER UNKNOWN

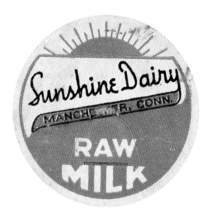

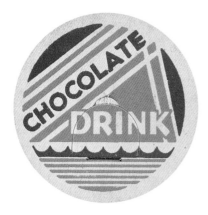

CHOCOLATE DRINK

BOTTLE CAP, C. 1939

DESIGNER UNKNOWN

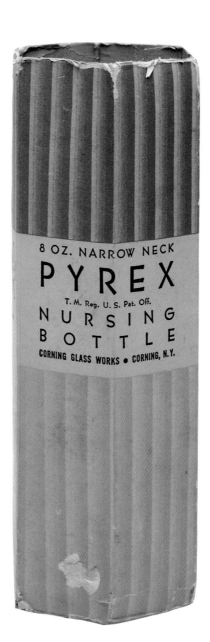

8 OZ. NARROW NECK

PYREX

T. M. Reg. U. S. Pat. Off.

NURSING
BOTTLE

CORNING GLASS WORKS • CORNING, N.Y.

PYREX

NURSING BOTTLE PACKAGE, 1930

DESIGNER UNKNOWN

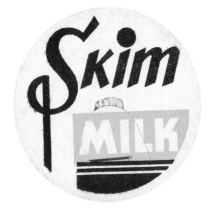

SKIM MILK

BOTTLE CAP, C. 1939

DESIGNER UNKNOWN

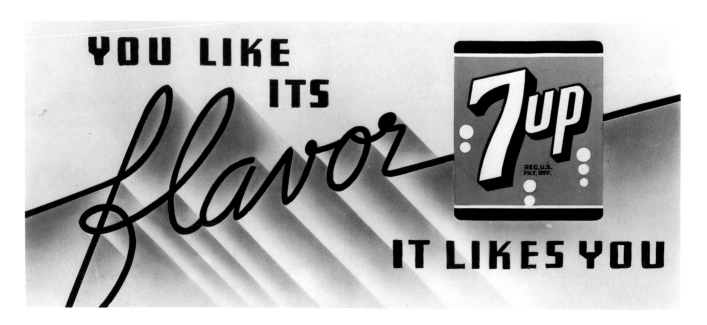

7-UP

BILLBOARD, C. 1938, DESIGNER UNKNOWN

LESLIE SALT

BILLBOARD, C. 1939, DESIGNER UNKNOWN

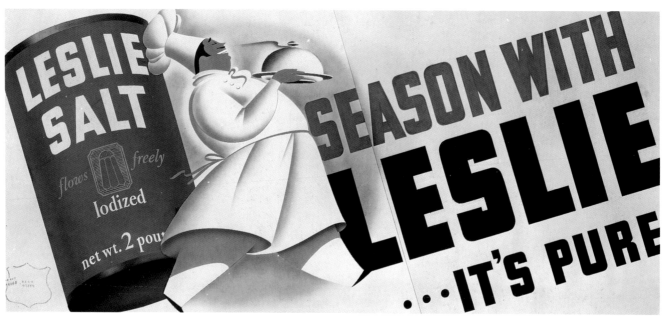

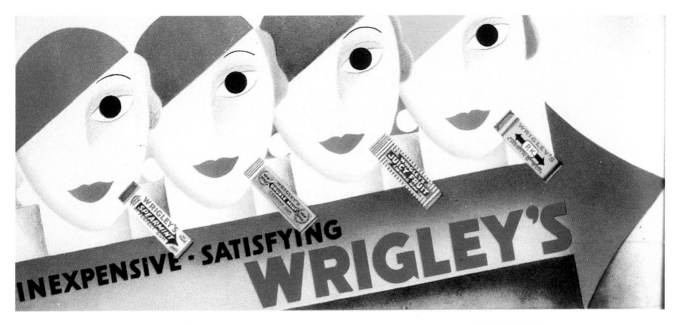

WRIGLEY'S

CAR CARD POSTER, 1934; DESIGNER: OTIS SHEPHERD

JU'CY ORANGE

CAR CARD POSTER, 1938; DESIGNER: LUCIAN BERNHARD

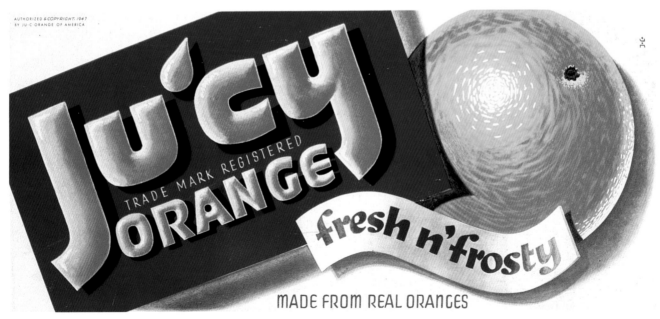

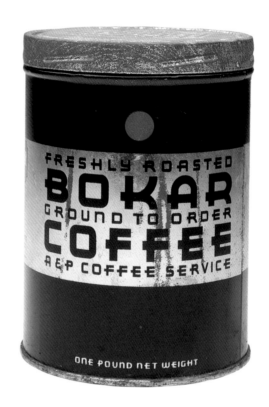

BOKAR COFFEE

PACKAGE, C. 1932

DESIGNER: EGMONT ARENS

RESTAURANTS LONGCHAMPS

CANDY PACKAGE, 1933

DESIGNER UNKNOWN

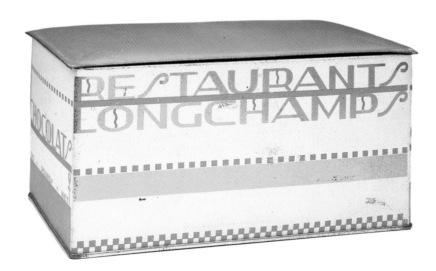

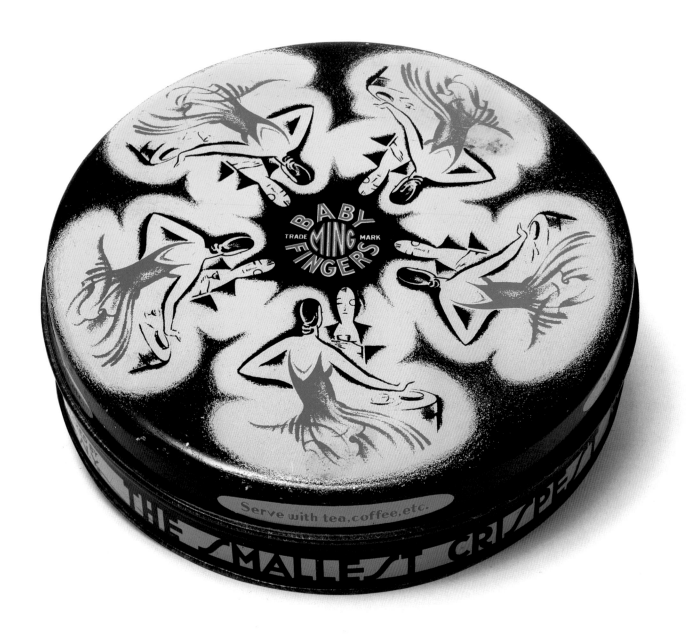

MING BABY FINGERS

COOKIE PACKAGE, 1932

DESIGNER UNKNOWN

In the 20s and 30s the corner drugstore was a veritable showplace of modernity. Advances in modern package engineering were displayed in the windows, on the counters, and along the aisles brimming with merchandise, often against cardboard sculptures of commerce known as point-of-purchase displays. Before television commercials for toothpastes, razor blades, shampoos, bath-soaps, deodorants, and mouthwashes hypnotized the American public into believing that it should enthusiastically maintain clean-looking and sweet-smelling bodies, the point-of-purchase display was, like a flower to the bee, designed to attract the potential consumer into sampling the newest product progress had to offer.

Modernity was expressed in packages through alluring, often dynamic, colors and patterns. What was referred to as "modern dress," unique when first introduced, developed into conventions that were copied throughout American business. In some

cases mimicry was excessive, which caused Frank H. Young to write in *Advertising Arts*, "Some enthusiasts take up a new idea like modernism and run away with it. . . . They imagine they are engaged in a contest . . . and try to outstrip all the others in eccentricity." In addition to the surface clichés, packages were also designed in various shapes and sizes to insure even greater brand distinction. Often resembling industrial designs, the modernistic drug or sundry package was not always functional but certainly contributed to the perpetuation of the Streamline style.

And yet the surface design was not the only issue of consequence; Egmont Arens asserted in *Advertising Arts* that package designers had to be "thoroughly grounded, not only in the matter-of-fact problems of production and merchandising but in the much deeper and subtler problems tackled by the sociologist and psychologist." Not only was the drugstore style a manifestation of fashion, it was a gateway to the American psyche.

STACOMB
HAIR TONIC PACKAGE, C. 1925
DESIGNER UNKNOWN

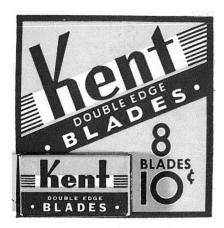

KENT

RAZOR BLADE PACKAGE, 1935

DESIGNER UNKNOWN

RUGBY

RAZOR BLADE DISPLAY, C. 1936

DESIGNER UNKNOWN

REM FOR COUGHS

CAR CARD POSTERS, 1937

DESIGNER: LUCIAN BERNHARD

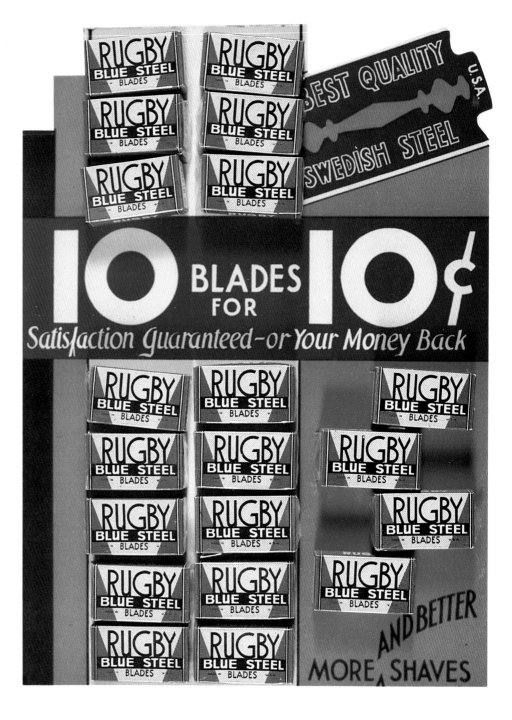

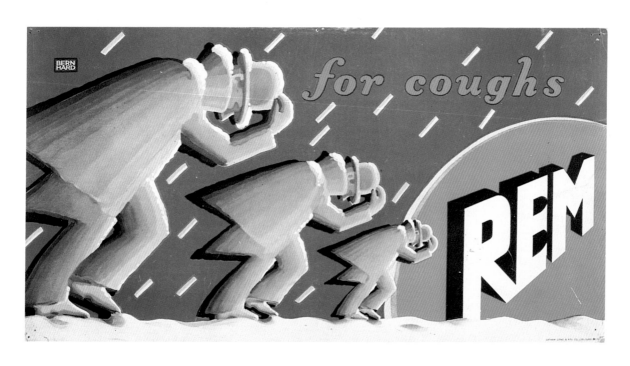

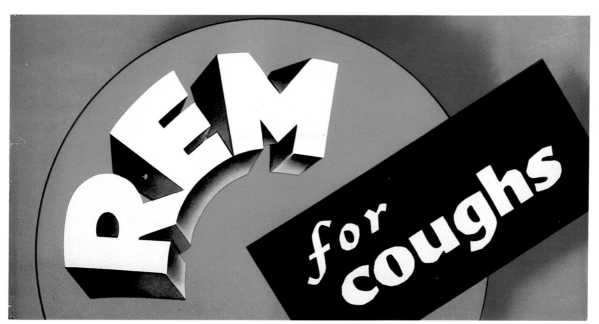

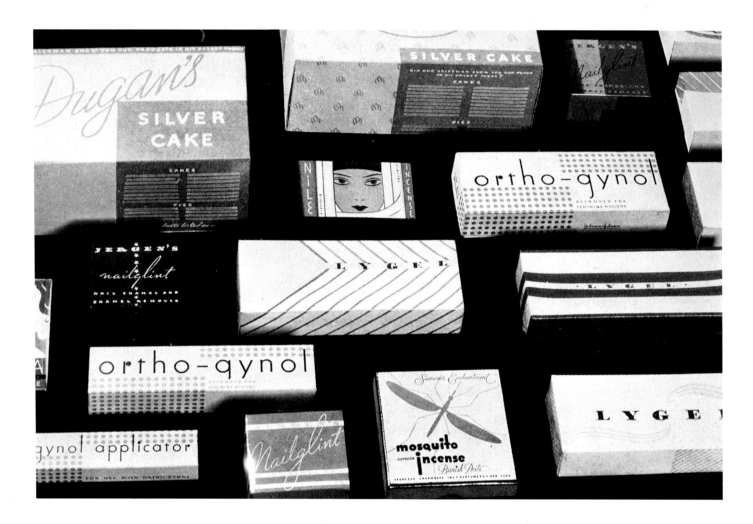

SUNDRIES

PACKAGES, C. 1933

DESIGNERS UNKNOWN

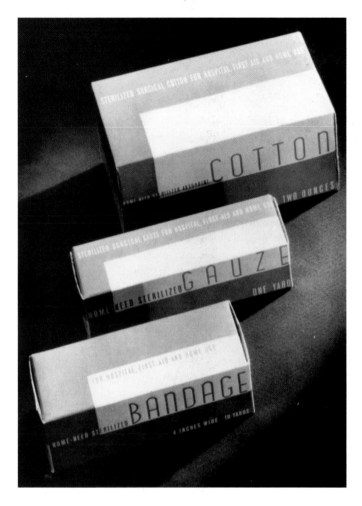

BANDAGE, GAUZE, COTTON

PACKAGES, C. 1933

DESIGNER UNKNOWN

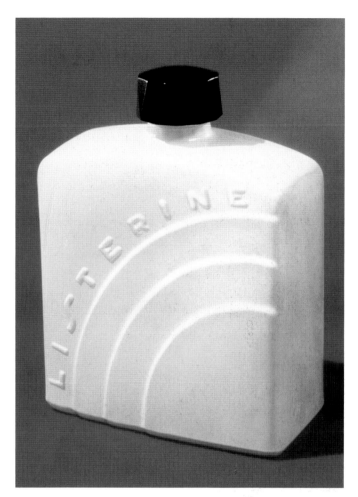

LISTERINE

PACKAGE, C. 1930

DESIGNER UNKNOWN

THE AMERICAN HAIRDRESSER

TRADE MAGAZINE COVER, 1930

DESIGNER: ROSS

FASHION ACADEMY

BROCHURE COVER, 1935

DESIGNER UNKNOWN

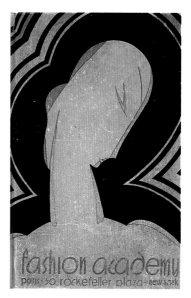

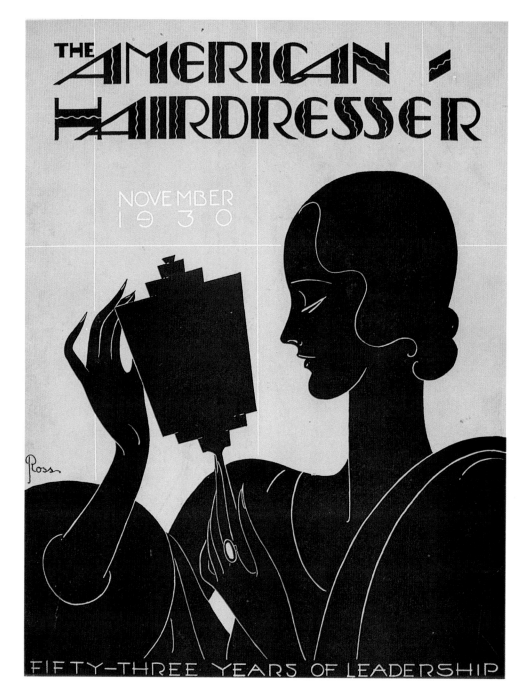

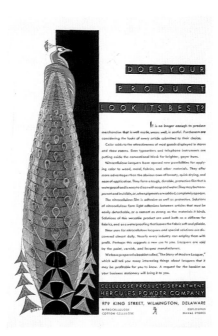

HERCULES POWDER CO.

ADVERTISEMENT, C. 1932

DESIGNER: BOBRI

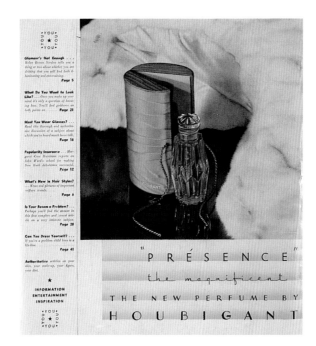

PRÉSENCE

PERFUME ADVERTISEMENT, 1935

DESIGNER UNKNOWN

"Ninety-nine per cent of all the makers of kitchen stoves, radiators, loudspeakers, sewing machines, match boxes, etc., think as Henry Ford did before he was forced by his competitors to bring out his attractive new car," wrote Lucian Bernhard in "Putting Beauty into Industry" (*Advertising Arts*). "The more efficient [industrialists] are in the business of manufacturing . . . the less time and desire they have to educate themselves in the field of aesthetics. The whole of idea of letting an 'artist' interfere is repellent to them . . . they hate to turn over a mechanically perfect product to an outsider in order that he may improve its form and color." Such was the initial response to the inclusion of "art in industry," a phrase that soon became the clarion of the industrial designer who brought Modern aesthetics to everyday products.

Covered in exciting patterns and molded in unique shapes these products were often advertisements for themselves. "To create a new beauty in machine

products has pointed the way to new life in industrial merchandising," continued Bernhard. Yet industrial design was initiated not by forward-thinking businessmen but through clever advertisers and packagers who transformed Modernism into a commodity. Selling the public on the promise of new wares required that the artist for industry first had to whet its appetite through seductive imagery and ornament. The stage for this visual sales pitch was world's fairs, three of which were held in Chicago (1933), San Francisco (1939), and New York (1939). Each was designed to evoke confidence in progress as expressed through the state of the arts. The wonders of industrial art were introduced at Chicago's "A Century of Progress" but New York's "The World of Tomorrow" marked both the zenith and apotheosis of the Streamline style.

NO WASTED CURRENT

on the bulb

ELECTRIC LAMPS

D FOR LAMPS?

MAZDA LAMPS
LIGHT BULB DISPLAY, 1925
DESIGNER UNKNOWN

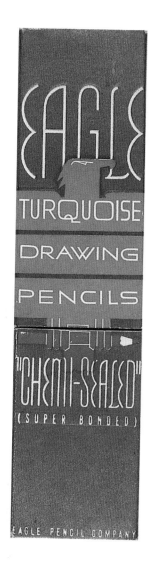

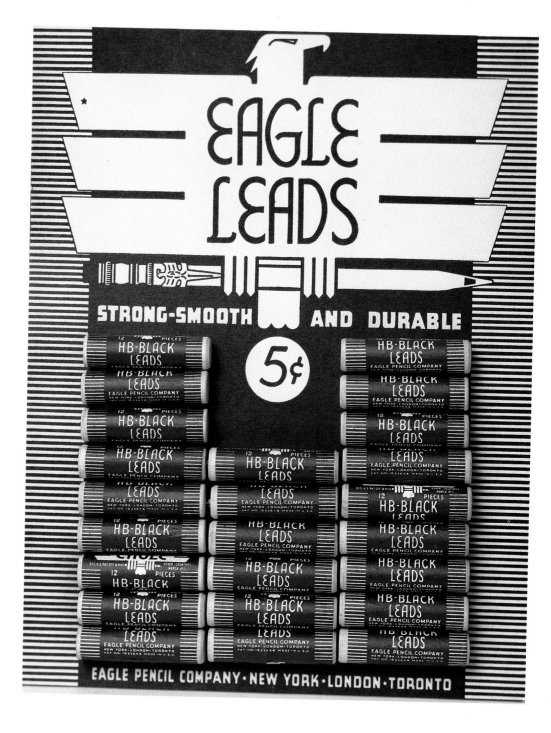

EAGLE TURQUOISE PENCILS

PACKAGE, C. 1938

DESIGNER: ROBERT FOSTER

EAGLE LEADS

POINT-OF-PURCHASE

DISPLAY, C. 1934

DESIGNER: ROBERT FOSTER

SEMI-HEX Pencils

SEMI-HEX ⊙ GENERAL PENCIL CO. U.S.A. 498-No 2

SMOOTHEST OF LEADS
COMFORTABLE TO HOLD
(Rounded Edges)

E. WINTER'S SONS, INC.
326 Wall Street
Kingston, N. Y.

SEMI-HEX PENCILS

ADVERTISING BLOTTER, 1936

DESIGNER UNKNOWN

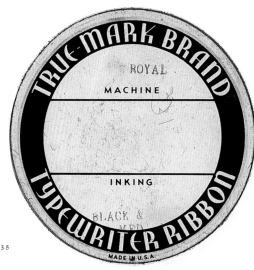

TRUE MARK BRAND

TYPEWRITER RIBBON PACKAGE, C. 1935

DESIGNER UNKNOWN

GE

APPLIANCE CATALOG

AND RECIPE BOOK, 1937

DESIGNER UNKNOWN

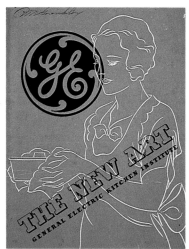

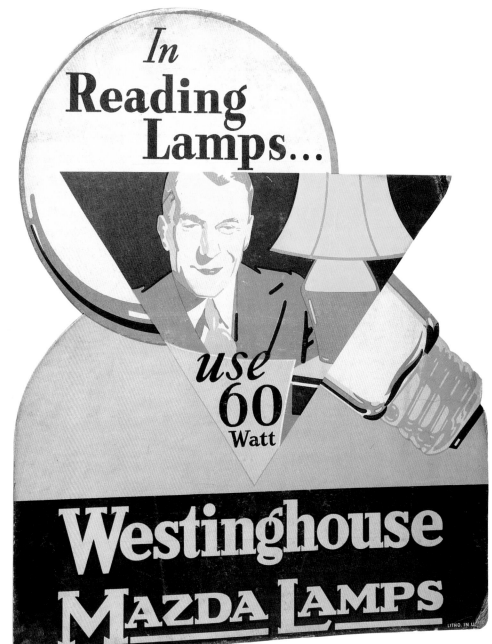

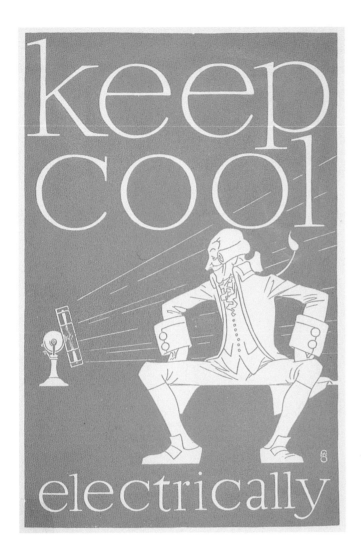

KEEP COOL

NEW YORK EDISON ADVERTISEMENT, 1927

DESIGNER: F.G. COOPER

IRON ELECTRICALLY

NEW YORK EDISON ADVERTISEMENT, 1927

DESIGNER: F.G. COOPER

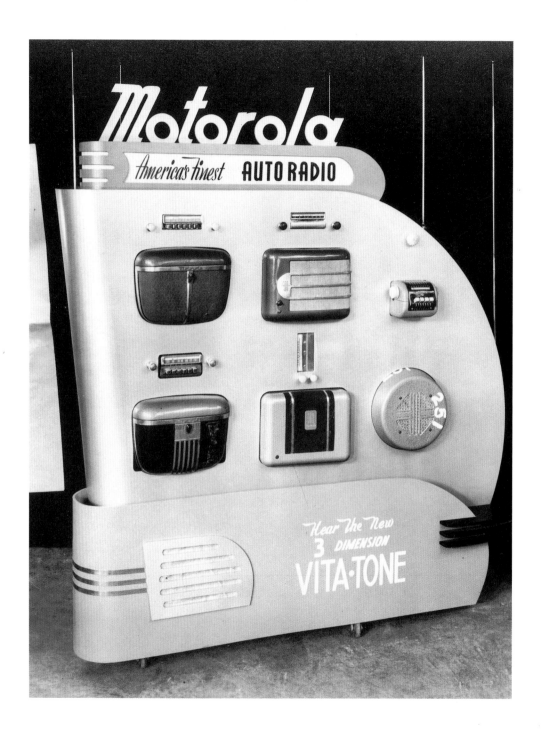

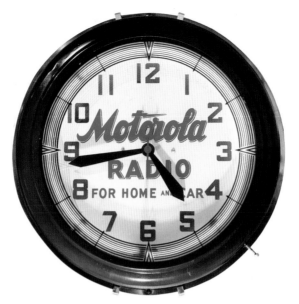

MOTOROLA RADIO

CLOCK, 1939

DESIGNER UNKNOWN

MOTOROLA AUTO RADIOS

STORE BANNER, 1940

DESIGNER UNKNOWN

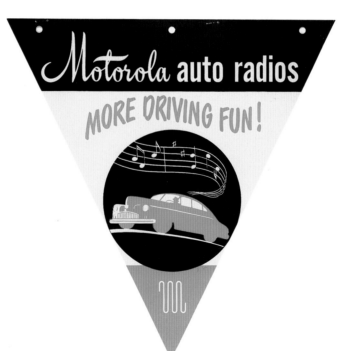

PIONEERING

n Important Era In Main Line
tion »»»» 1905

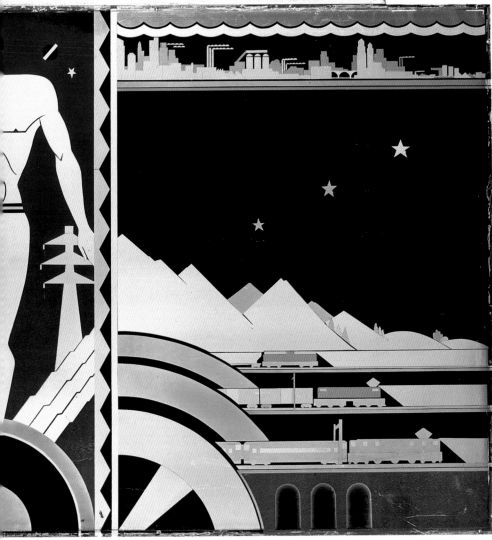

1939
WORLD'S FAIR
ON SAN FRANCISCO BAY

GOLDEN GATE INTERNATIONAL EXPOSITION

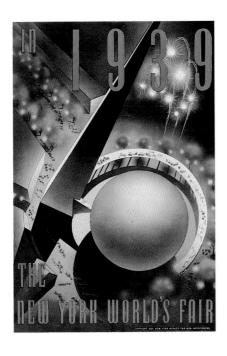

1939 NEW YORK WORLD'S FAIR

POSTER, 1939

DESIGNER: NEMBHARD N. CULIN

NEW YORK WORLD'S FAIR

POSTER, 1939

DESIGNER: JOSEPH BINDER

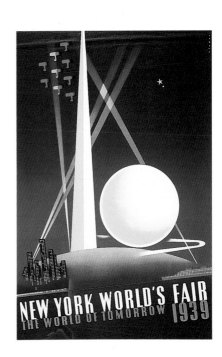

NEW YORK WORLD'S FAIR

POSTER, 1939

DESIGNER: JOHN ATHERTON

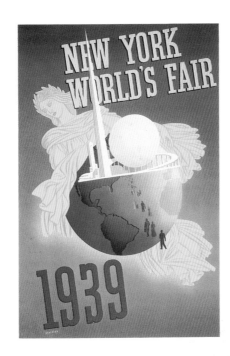

1939 WORLD'S FAIR

POSTER, 1939

DESIGNERS:

SHAWEL, NYELAND & SEAVY

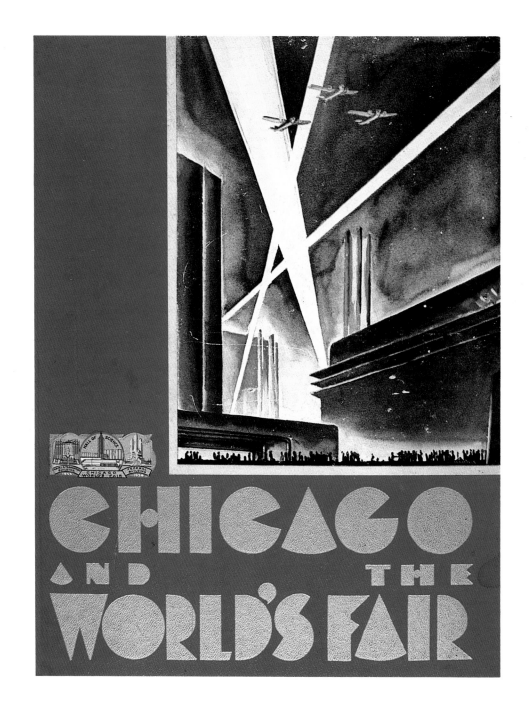

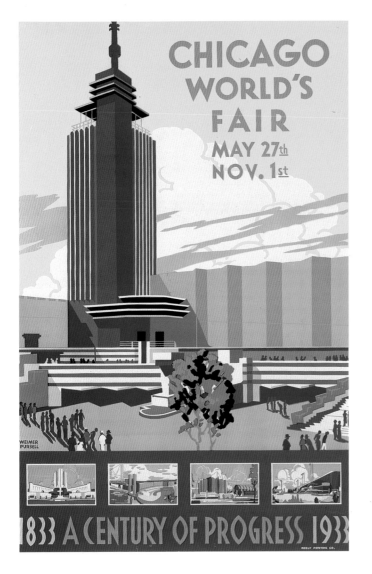

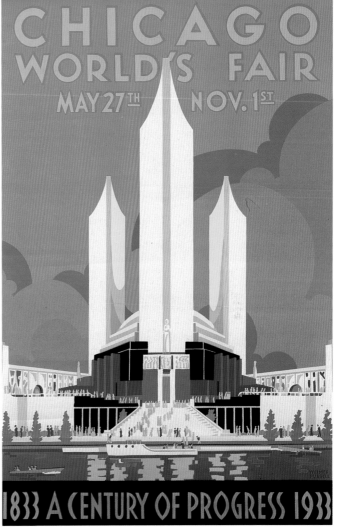

CHICAGO WORLD'S FAIR

POSTER, 1933

DESIGNER: WEIMER PURSELL

CHICAGO WORLD'S FAIR

POSTER, 1933

DESIGNER: WEIMER PURSELL

CHICAGO AND THE WORLD'S FAIR

BOOK COVER, 1933

DESIGNER UNKNOWN

A CENTURY OF PROGRESS. CHICAGO
BOOK COVER, 1933
DESIGNER: JOSEPH P. BIRREN

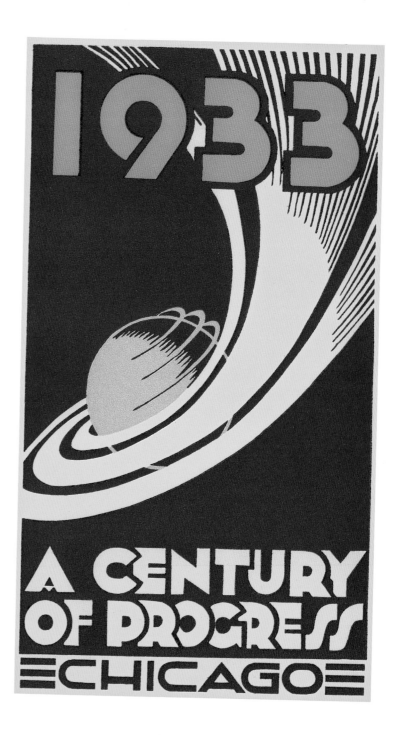

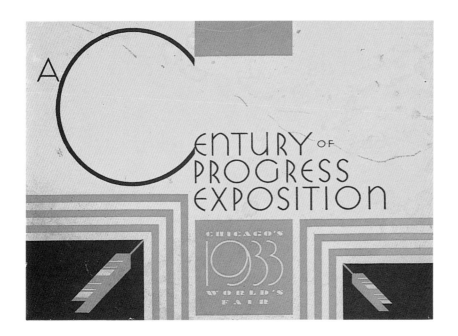

A CENTURY OF PROGRESS EXPOSITION
CATALOG COVER, 1933
DESIGNER UNKNOWN

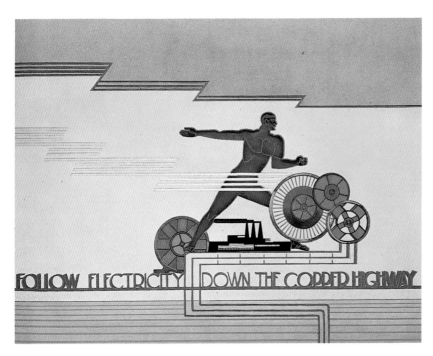

FOLLOW ELECTRICITY . . .
PAGE FROM GUIDEBOOK, 1933
DESIGNER UNKNOWN

Streamline design was based on aerodynamic principles and evoked a sense of speed. It was at once the engine of progress and a metaphor for the fast tempo of daily life. For example, Henry Dreyfus's 1938 streamlined "Engine 5450" and Raymond Lowey's 1938 "S-1" radically departed from the old-fashioned locomotive not only in look but in sound — for even the name given to one of Lowey's most legendary trains, *The 20th Century Limited,* suggested unlimited travel possibilities. Moreover, the swooped backs and thrusting grills of the Chrylser Airflow and Lincoln-Zephyr V-12 automobiles distinguished them from the horseless carriage style that had become a timeworn cliché. Styling became an integral way for this and other transportation industries to appeal to the public. Indeed, streamlining underscored the fact in the public's mind that this was America's transportation age.

Transportation was the cornerstone of American progress, and interstate highways, railway systems, and airplane and ship routes were integral to achieving this goal. Urban planners promoted a future that was inextricably tied to the transportation industries, which in turn increasingly pushed their new mechanical wares on the consumer through

modern dress. Consumer engineering was nowhere more effectively practiced than in the automobile industry, and style obsolescence became the quintessential marketing strategy, indeed ideology. The graphics used to sell automobiles employed modernistic motifs to at once stress utility and luxury. Many of the same tropes were extended to petroleum products and tires to express efficiency. As Earnest Elmo Calkins predicted, typography and graphics created various auras to attract and seduce the consumer not into buying merely a piece of machinery, but speed, not just a simple conveyance, but a Modern chariot, not just gas, but a magical elixir. Similarly, the posters, brochures, and road maps that promoted interstate travel were adorned with mythic streamlined images of great Modern metropolises rendered in airbrush that symbolized the flawless grandeur of the Machine Age.

STANDARD OIL

STANDARD OIL
OIL TRUCK, 1937
DESIGNER UNKNOWN

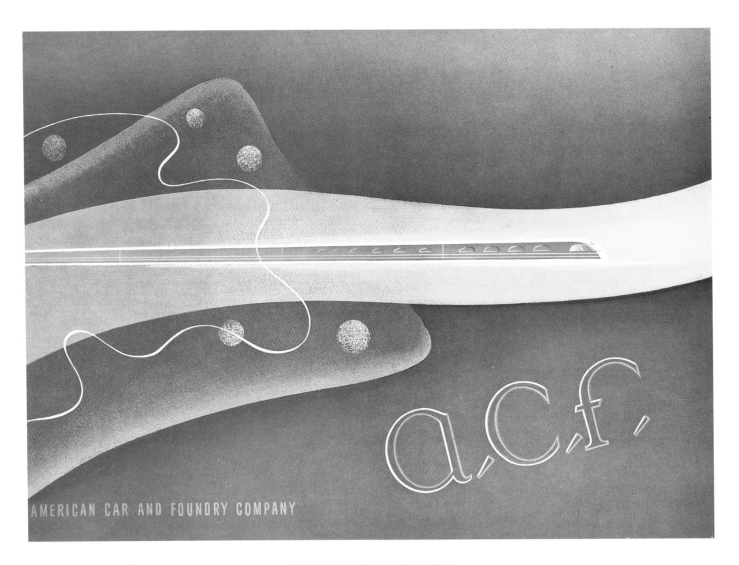

AMERICAN CAR AND FOUNDRY

CATALOG COVER, 1938

DESIGNER: LEO RACKOW

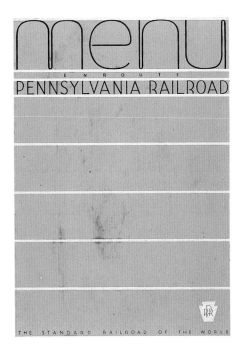

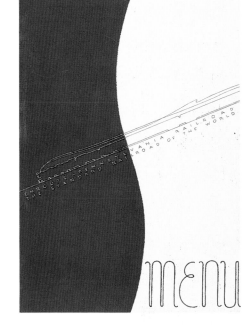

PENNSYLVANIA RAILROAD

MAQUETS FOR MENU, 1935 •

DESIGNER: RAYMOND LOWEY

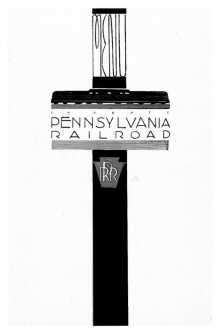

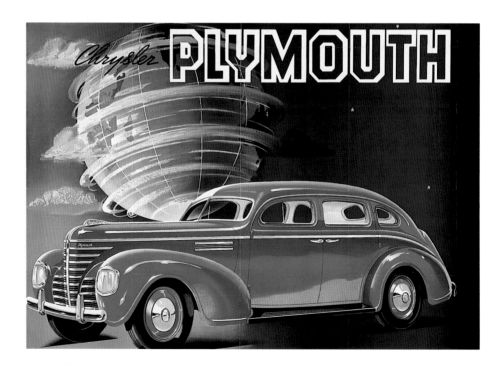

PLYMOUTH
POSTER, 1934
DESIGNER UNKNOWN

PLYMOUTH
POSTER, 1939
DESIGNER UNKNOWN

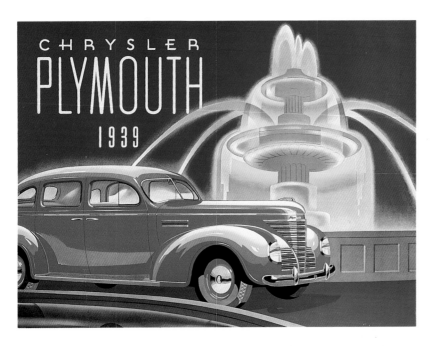

PLYMOUTH
POSTER, 1939
DESIGNER UNKNOWN

CHRYSLER
POSTER, 1939
DESIGNER UNKNOWN

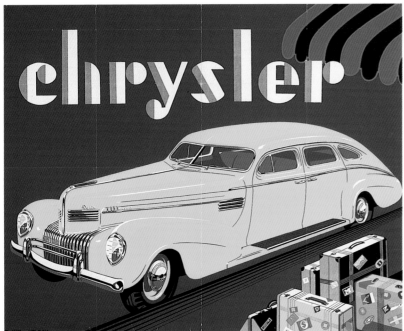

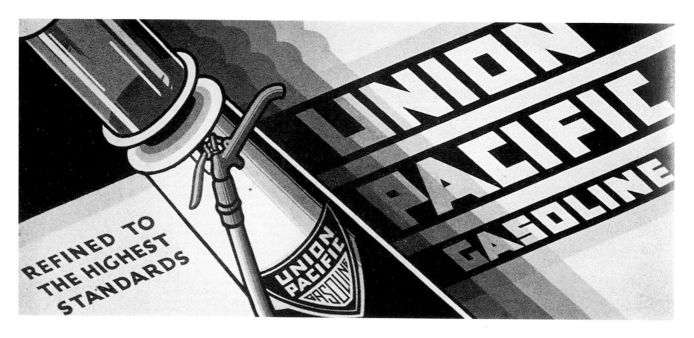

UNION PACIFIC GASOLINE

BILLBOARD, 1930; DESIGNER: C. MAURICE MAYER

MOBILGAS

BILLBOARD, 1930; DESIGNER: POUSETTE-DART

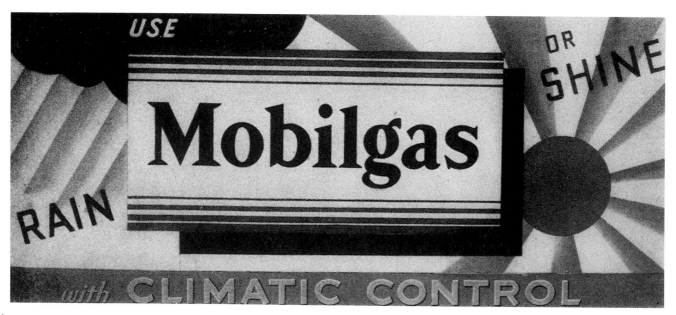

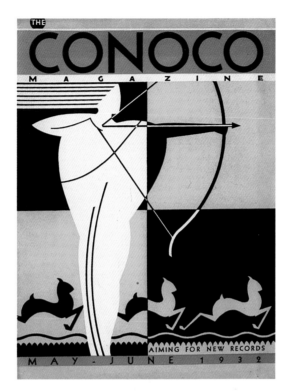

CONOCO

CORPORATE MAGAZINE COVER, 1932

DESIGNER UNKNOWN

ATLANTIC MOTOR OIL

BILLBOARD, C. 1932

DESIGNER UNKNOWN

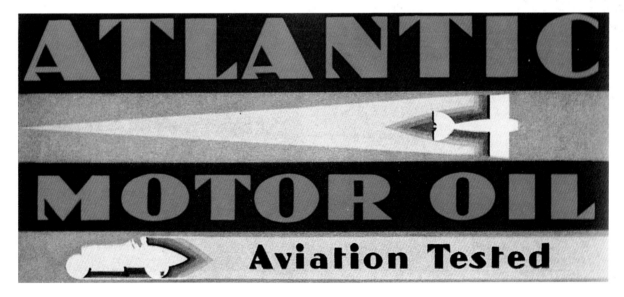

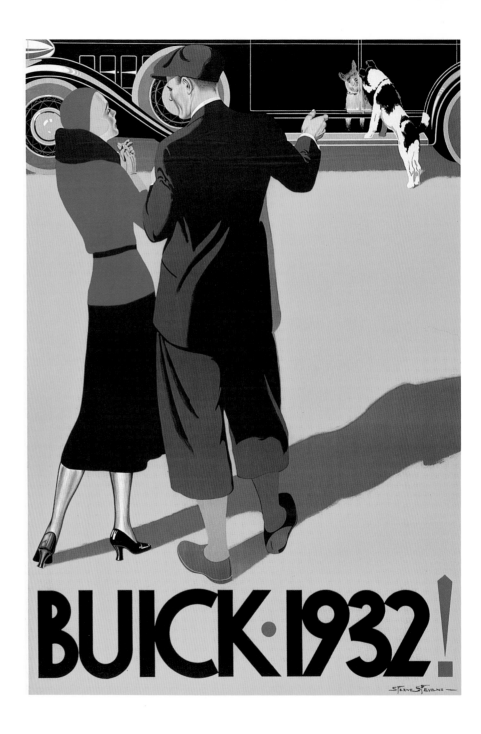

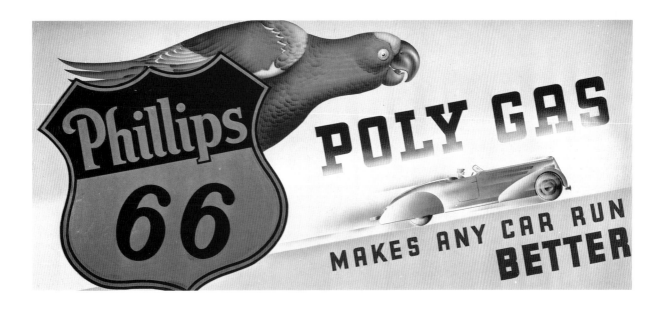

POLY GAS

BILLBOARD, 1938

DESIGNER UNKNOWN

LINCOLN-ZEPHYR V-12

BILLBOARD, 1938

DESIGNER UNKNOWN

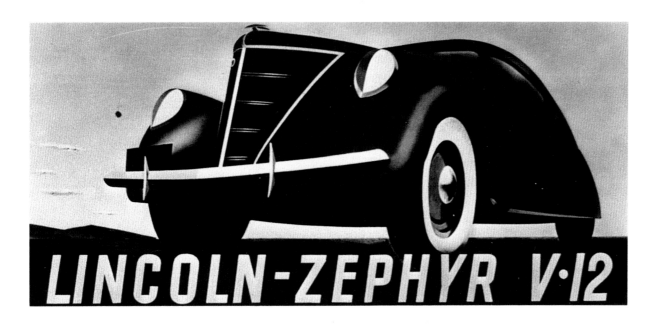

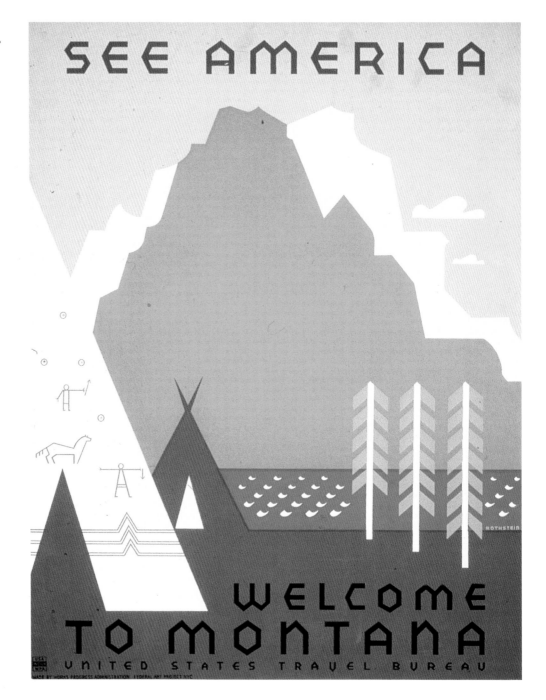

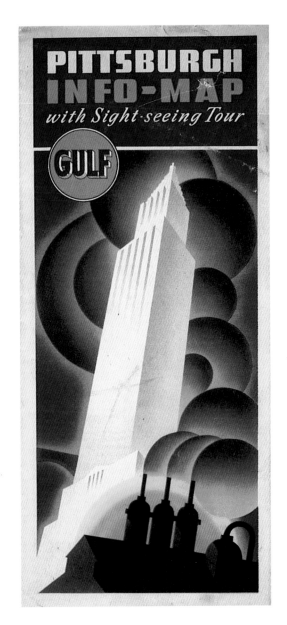

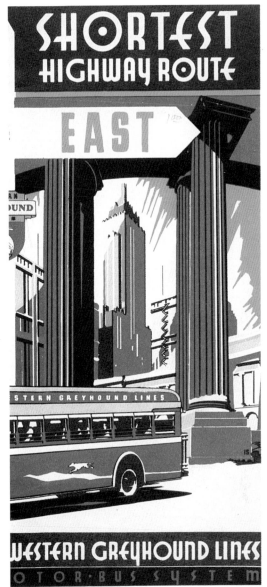

PITTSBURGH

GULF ROAD MAP, C. 1937

DESIGNER UNKNOWN

SHORTEST HIGHWAY ROUTE

GREYHOUND BUS SCHEDULE, C. 1933

DESIGNER UNKNOWN

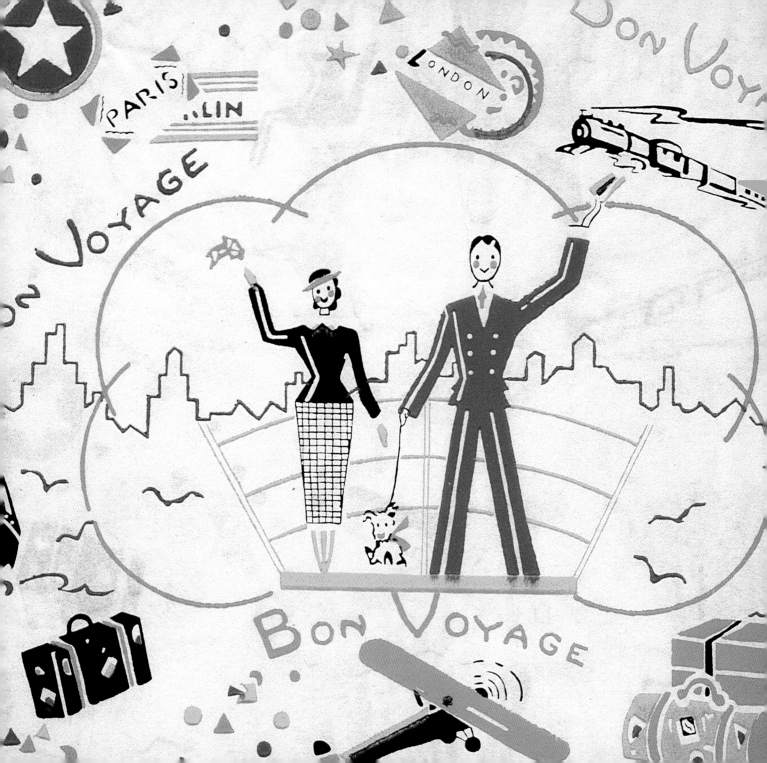

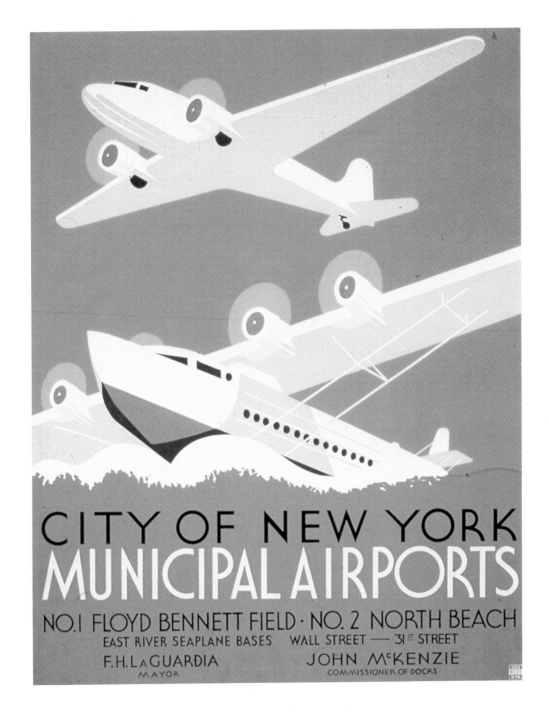

CITY OF NEW YORK
MUNICIPAL AIRPORTS
POSTER, 1937
DESIGNER: HARRY HERZOG

FACING PAGE:
BON VOYAGE
WRAPPING TISSUE, C. 1932
DESIGNER UNKNOWN

During the depth of the Depression President Roosevelt formed the WPA (Works Progress Administration) to create jobs for the masses of unemployed. Under its banner the Federal Art Project hired thousands of artists to create paintings and murals for public institutions, including post offices, hospitals, and airports. Many of these works that depicted American past and present life are permanent monuments to a difficult era. In addition, scores of artists were employed to create more ephemeral works, such as posters that announced a range of civic and cultural activities from lectures to concerts to theater programs. Thousands of posters were designed, millions were distributed, and most conformed to a prevailing national graphic style. What was known as the WPA Style, a synthesis of European Modern, commercial moderne, and heroic realism, noteworthy for its asymmetrical typography, airbrushed lettering, and silkscreened imagery, dressed bulletin boards and poster hoardings. They brought a certain sparkle to an otherwise dark period of history. Other economically expressive design characteristics were borrowed from the essential geometries found in Russian

constructivism and Dutch de Stijl. Often type, letterforms, and composition itself were lifted from German and French poster or trademark design.

The cultural arena was fertile ground for designers working in the modernistic style. They were given a modicum of license to push the boundaries yet at the same time were required to conform to accepted tastes. The range of design solutions represented here for books, music, and magazines of various themes illustrate how individual artists altered the prevailing modernistic style to answer personal and commercial needs. Despite a general stylistic conformity, each genre being addressed retained a certain individuality. Cultural projects were not as constrained by the advertising stylists, who by the mid-1930s were followers rather than leaders, for these were not market-driven products and commodities. But even where marketing was an important factor, such as with record album artwork or book cover design, the graphics ran the gamut from doggedly conformist to delightfully experimental.

JOY·RIDE!
BOOK JACKET, 1929
DESIGNER: D. H.

PAUL WHITEMAN

POSTER ADVERTISING RECORDS, 1924

DESIGNER: LEO FULLER

FRANKIE COLE ENCORES

RECORD ALBUM COVER, 1942

DESIGNER: ALEX STEINWEISS

RHAPSODY IN BLUE

RECORD ALBUM COVER, 1946

DESIGNER: ALEX STEINWEISS

BOOGIE WOOGIE

RECORD ALBUM COVER, 1943

DESIGNER: ALEX STEINWEISS

LA CONGA

RECORD ALBUM COVER, 1943

DESIGNER: ALEX STEINWEISS

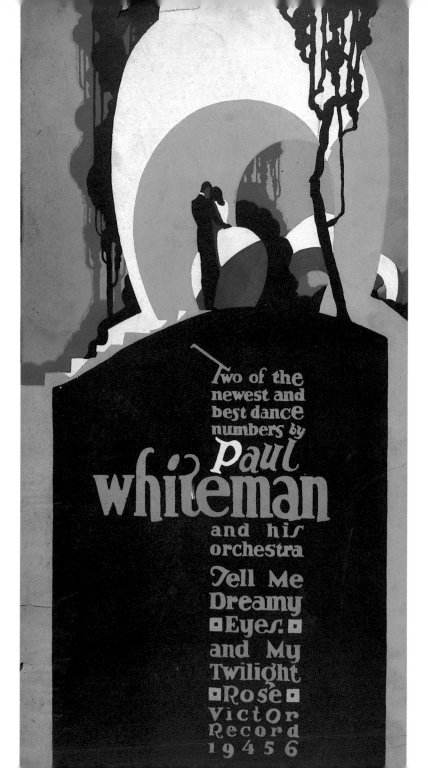

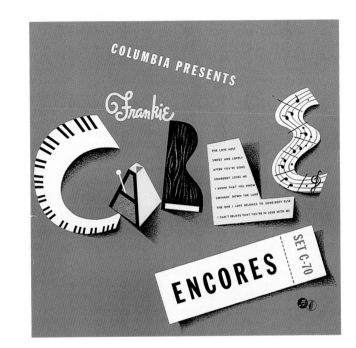

COLUMBIA PRESENTS

Frankie CARLE

THE LOVE NEST
SWEET AND LOVELY
AFTER YOU'VE GONE
SOMEBODY LOVES ME
I KNOW THAT YOU KNOW
SWINGIN' DOWN THE LANE
THE ONE I LOVE BELONGS TO SOMEBODY ELSE
I CAN'T BELIEVE THAT YOU'RE IN LOVE WITH ME

SET C-70

ENCORES

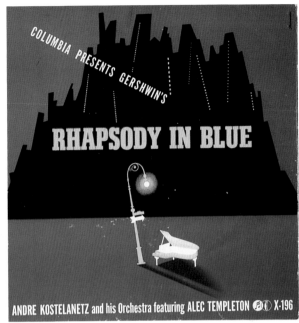

COLUMBIA PRESENTS GERSHWIN'S

RHAPSODY IN BLUE

ANDRE KOSTELANETZ and his Orchestra featuring ALEC TEMPLETON X-196

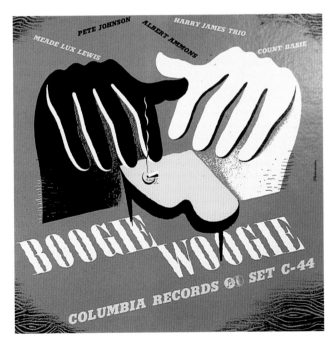

MEADE LUX LEWIS PETE JOHNSON HARRY JAMES TRIO
ALBERT AMMONS COUNT BASIE

BOOGIE WOOGIE

COLUMBIA RECORDS SET C-44

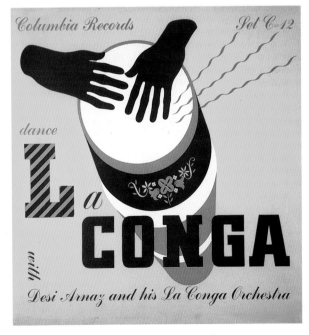

Columbia Records Set C-12

dance

La CONGA

with

Desi Arnaz and his La Conga Orchestra

THE DANCE

MAGAZINE COVER, 1929
DESIGNER: RITA LEECH

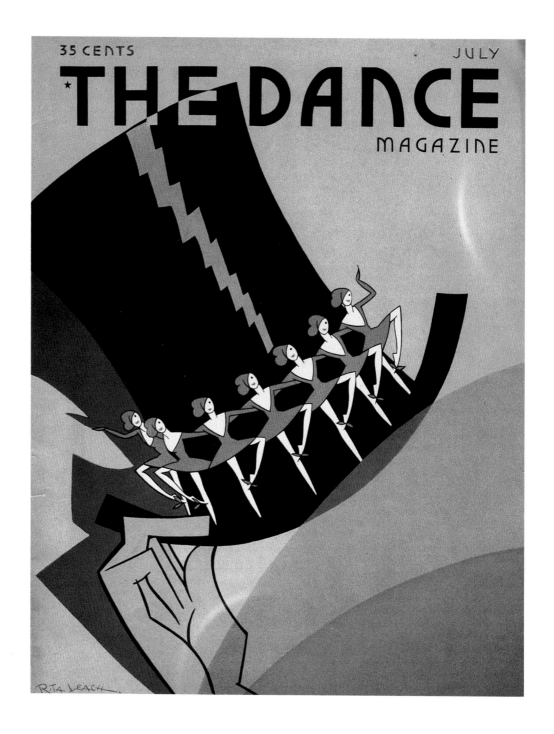

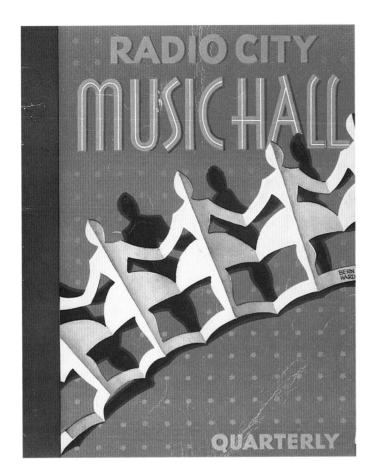

RADIO CITY MUSIC HALL QUARTERLY

PROGRAM COVER, 1937

DESIGNER: LUCIAN BERNHARD

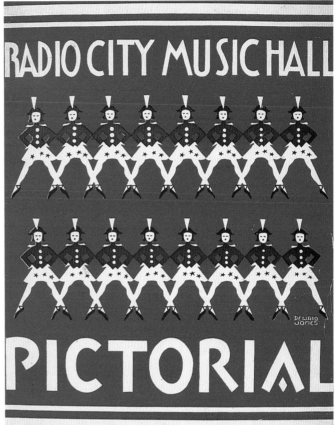

RADIO CITY MUSIC HALL PICTORIAL

PROGRAM COVER, 1938

DESIGNER: DEWARD JONES

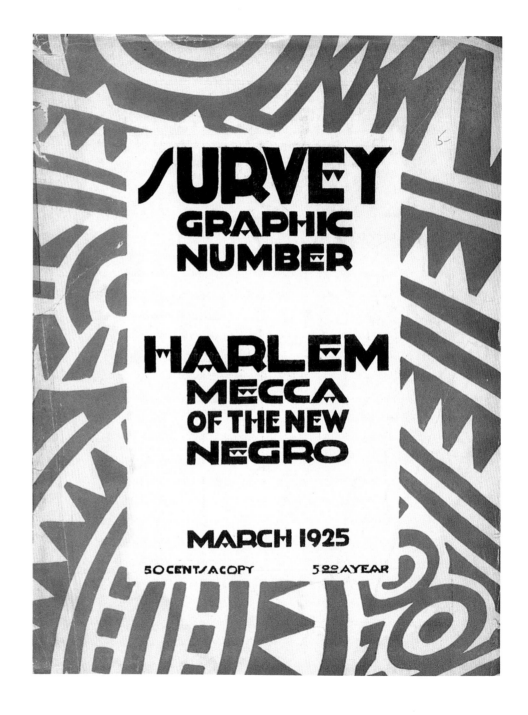

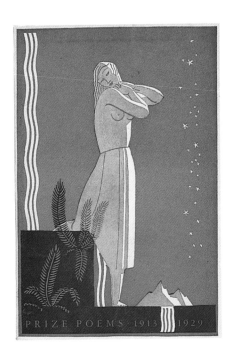

POEMS

PAPERBACK COVER, 1930

CHARLES BONI INC.

DESIGNER: ROCKWELL KENT

CRIME AND DESTINY

PAPERBACK COVER, 1930

CHARLES BONI INC.

DESIGNER UNKNOWN

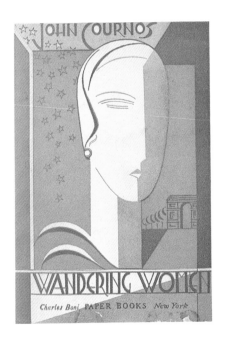

WANDERING WOMEN

PAPERBACK COVER, 1930

CHARLES BONI INC.

DESIGNER UNKNOWN

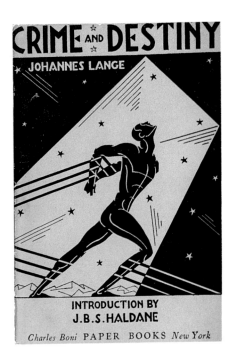

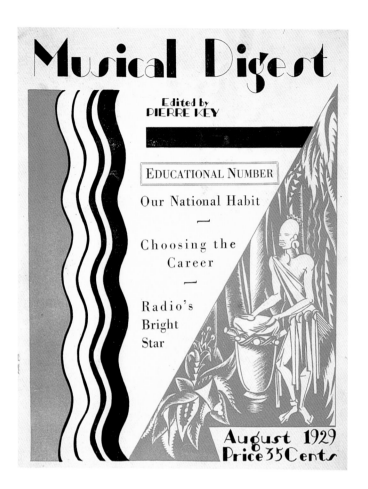

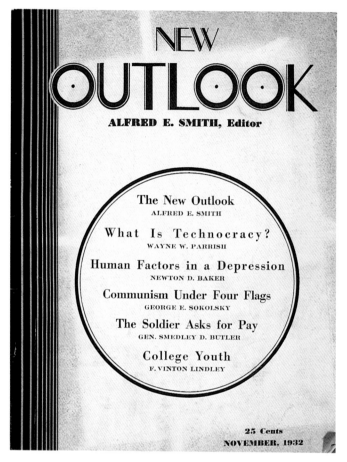

MUSICAL DIGEST

MAGAZINE COVER, 1929

DESIGNER UNKNOWN

NEW OUTLOOK

MAGAZINE COVER, 1932

DESIGNER UNKNOWN

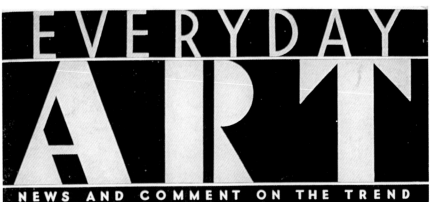

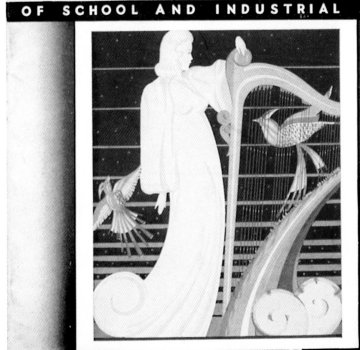

EVERYDAY ART

NEWS AND COMMENT ON THE TREND
OF SCHOOL AND INDUSTRIAL ARTS

DEC. 1938 - JAN. 1939

PUBLISHED BY
THE AMERICAN CRAYON COMPANY
SANDUSKY · OHIO · · · NEW YORK

EVERYDAY ART
CORPORATE MAGAZINE COVER, 1938
THE AMERICAN CRAYON CO.
DESIGNER: C. W. KNOUFF

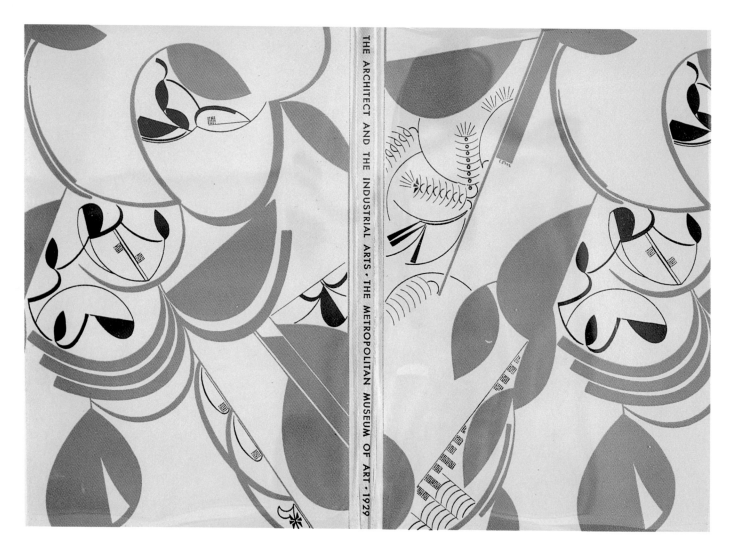

THE ARCHITECT & THE INDUSTRIAL ARTS

EXHIBITION CATALOG COVER, 1929

DESIGNER: WILLIAM ADDISON DWIGGINS

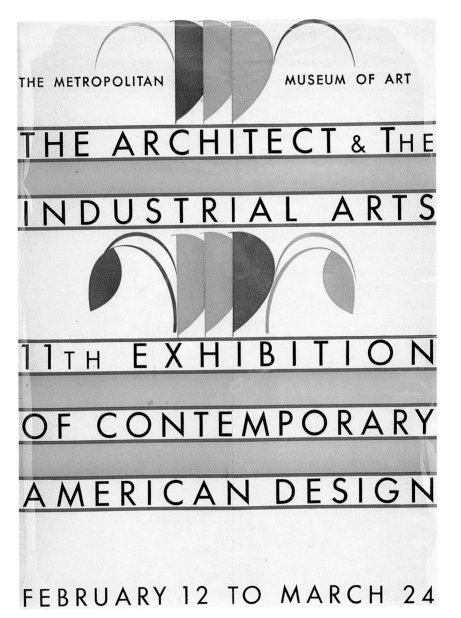

THE ARCHITECT & THE INDUSTRIAL ARTS
EXHIBITION POSTER, 1929
DESIGNER: WILLIAM ADDISON DWIGGINS

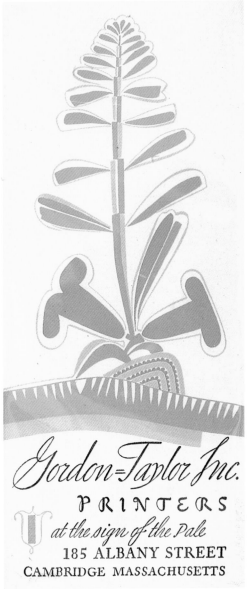

GORDON-TAYLOR INC.
PRINTER'S ADVERTISEMENT, C. 1929
DESIGNER: WILLIAM ADDISON DWIGGINS

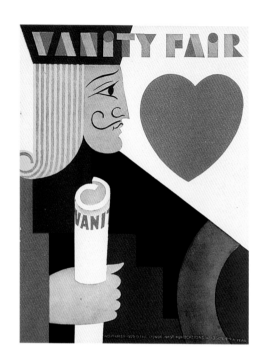

VANITY FAIR

MAGAZINE COVER, 1929

DESIGNER: M. F. AGAH

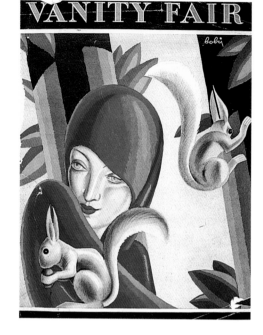

VANITY FAIR

MAGAZINE COVER, 1928

DESIGNER: BOBRI

VANITY FAIR

MAGAZINE COVER, 1926

DESIGNER: DARCY

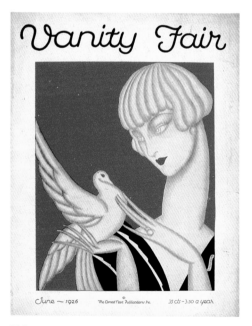

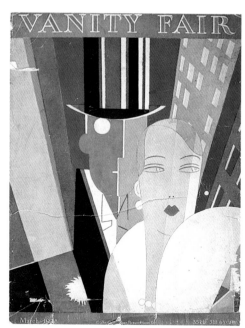

VANITY FAIR

MAGAZINE COVER, 1928

DESIGNER: EDUARDO BENITO

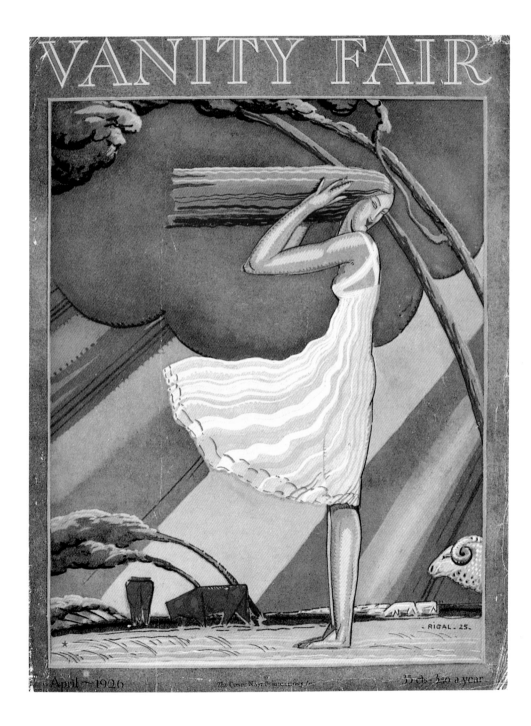

VANITY FAIR
MAGAZINE COVER, 1926
DESIGNER: RIGAL

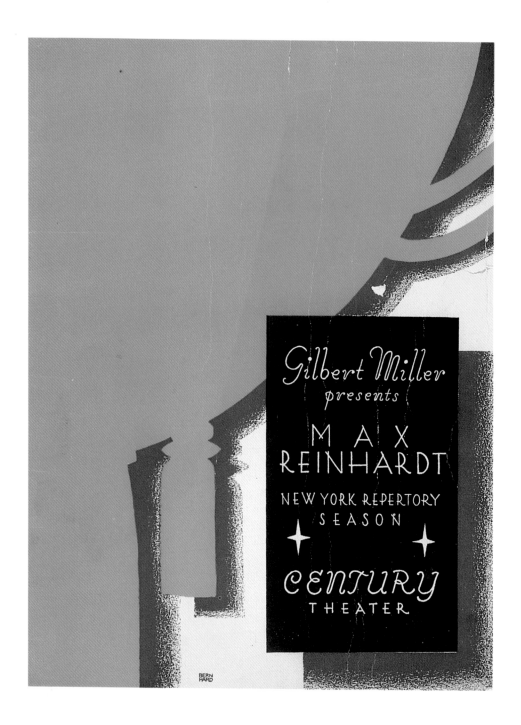

Gilbert Miller
presents
MAX
REINHARDT
NEW YORK REPERTORY
SEASON
CENTURY
THEATER

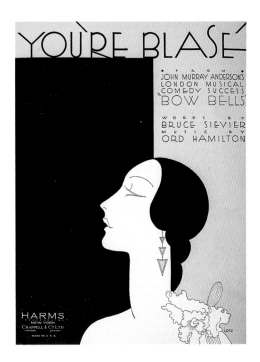

YOU'RE BLASÉ

SHEET MUSIC, C. 1930

DESIGNER: JORS

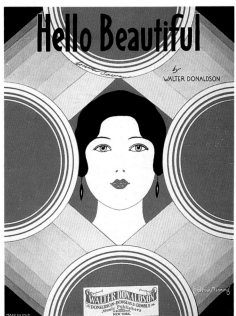

HELLO BEAUTIFUL

SHEET MUSIC, 1931

DESIGNER: FREDERICK MANNING

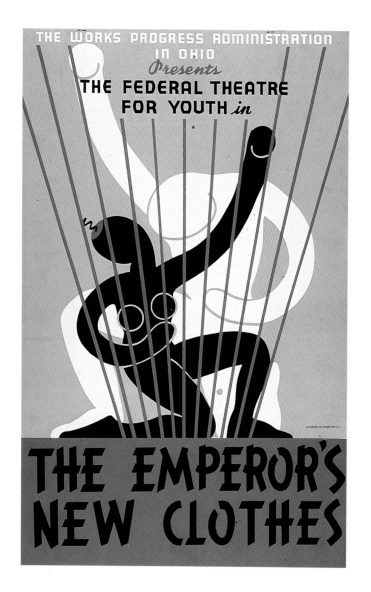

THE EMPEROR'S NEW CLOTHES

FEDERAL THEATER PROJECT POSTER, C. 1936

DESIGNER: HARRY REMINICK

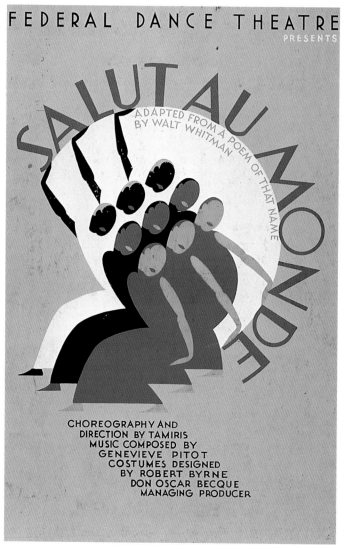

SALUT AU MONDE

FEDERAL DANCE THEATER POSTER, C. 1936

DESIGNER UNKNOWN

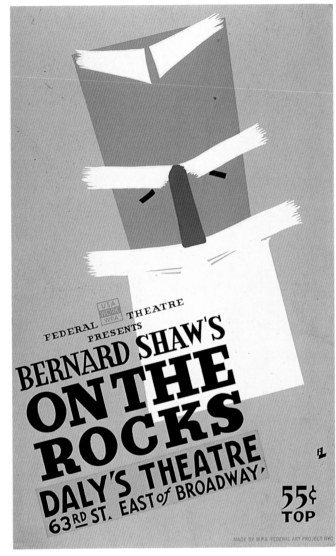

ON THE ROCKS

FEDERAL THEATER PROJECT POSTER, C. 1936

DESIGNER: BEN LASSEN

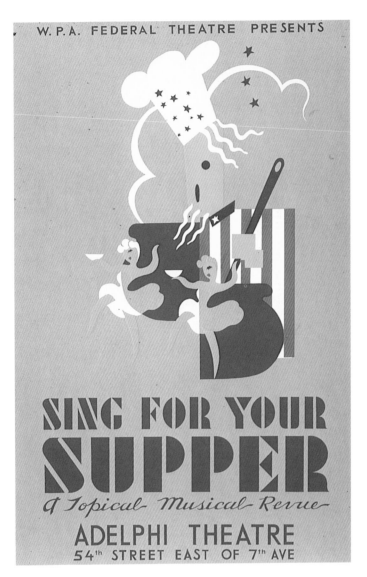

SING FOR YOUR SUPPER

FEDERAL THEATER PROJECT POSTER, C. 1936

DESIGNER: AIDA McKENZIE

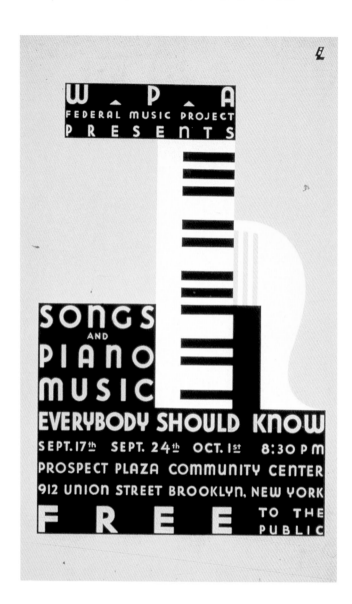

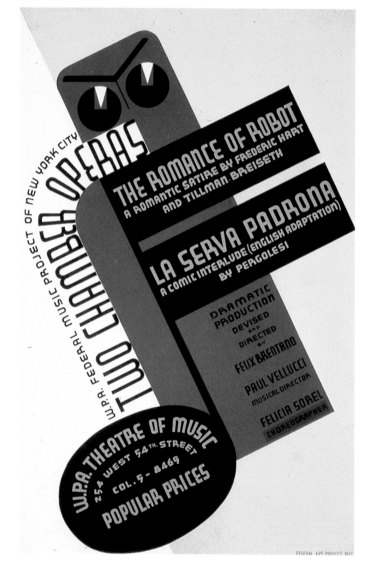

SONGS AND PIANO MUSIC

FEDERAL MUSIC PROJECT POSTER, C. 1936

DESIGNER: BEN LASSEN

TWO CHAMBER OPERAS

FEDERAL MUSIC PROJECT POSTER, C. 1936

DESIGNER UNKNOWN

FREE BAND CONCERTS

FEDERAL MUSIC PROJECT POSTER, 1937, DESIGNER UNKNOWN

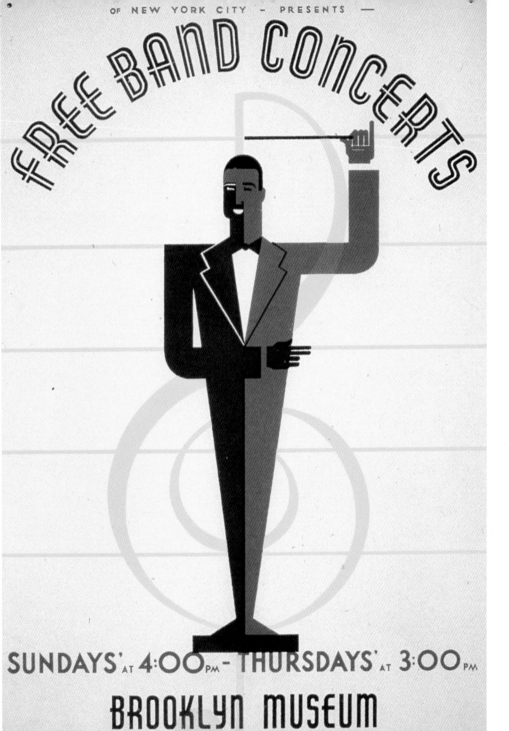

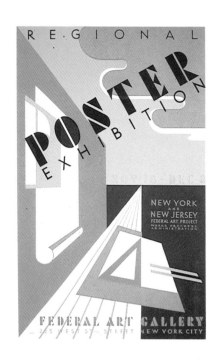

POSTER EXHIBITION

FEDERAL ART GALLERY POSTER, 1937

DESIGNER: RICHARD FLOETHE

POSTERS AND ART PROCESSES

FEDERAL ART GALLERY POSTER, C. 1937

DESIGNER UNKNOWN

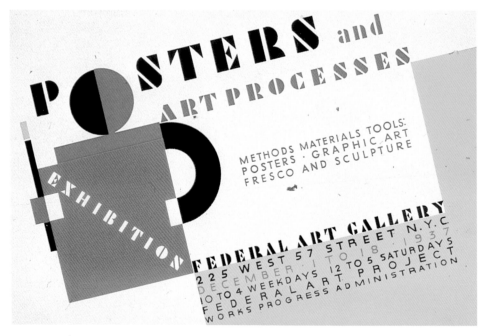

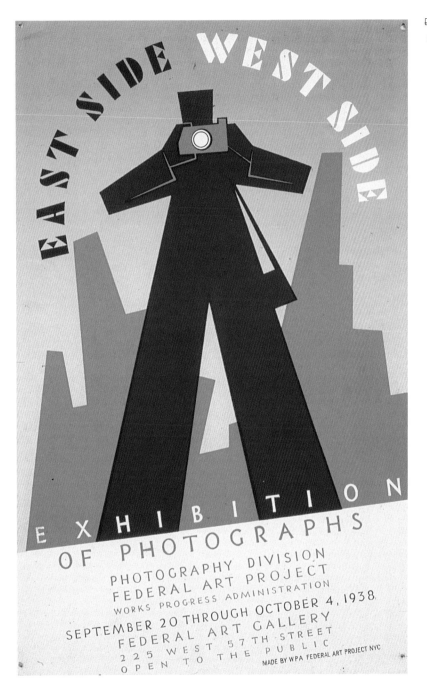

"The truth is that modern typography is all wound round with thou-shalts and thou-shalt-nots, and the really good piece of modern typography is fairly simple and sane. It's not easy to do; it only looks easy," wrote Edmund G. Gress in *Fashions in American Typography 1780–1930*. Gress, the editor of the *American Printer,* was suggesting that the best of modern typography was not mired in rules and regulations, it strove for simplicity. Just as the Greeks left off the nonessentials in architecture, Modern typographers were ridding themselves of excess. However, he wrote, "we must not simplify to such an extent that life and movement are gone. That is where those persons go wrong who claim that type was made to read, and nothing else matters but the setting up of a paragraph in legible type so that it can be easily read. We do not read everything that appears in print, but do read that which appears interesting." And this underscores the tension between purely geometric typography promoted by the Modern movement and the raucous exuberance of the moderne.

The Moderns rejected what Douglas C. McMurtrie called in *Modern Typography and Layout* "the stranglehold of tradition," because the models based on past glories were "held so close in the vise . . . that it can hardly wiggle." Central axis composition and serif typefaces were not yet obsolete, but were applied to staid aspects of printing and design. "We have no criticism of the best of past generations," continued McMurtrie, "the only question is whether the styles then used are in consonance with the spirit and tempo of the present age, or whether typography based on those styles meets the demands of contemporary life." The outpouring from European foundries and American type shops of Modern and modernistic letterforms offered the designer greater options and more chances to create the dynamic layouts. Indeed, typefaces were promoted to printers through specimen sheets with all the fanfare of a souped up advertising campaign. And it was the mission of type leaders to alter the practice of their followers.

WHEN IT RAINS IT POURS
ADVERTISING BLOTTER,
C. 1935
DESIGNER UNKNOWN

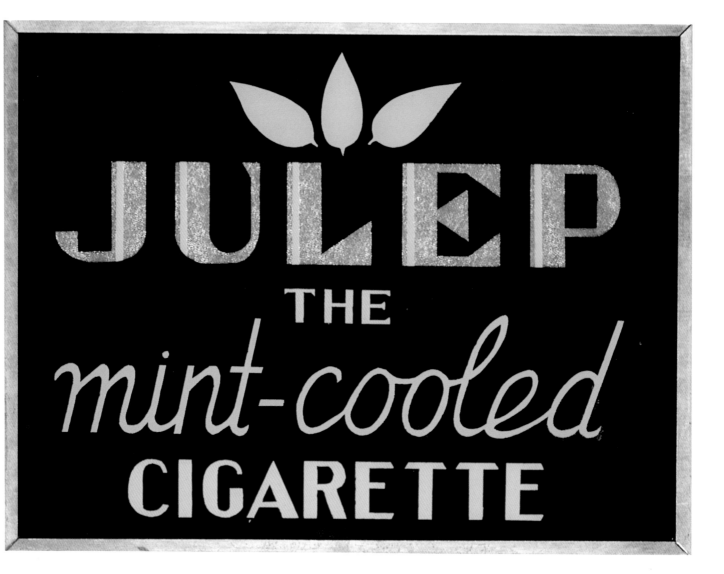

JULEP

ADVERTISING SIGN (ON GLASS), 1928

DESIGNER UNKNOWN

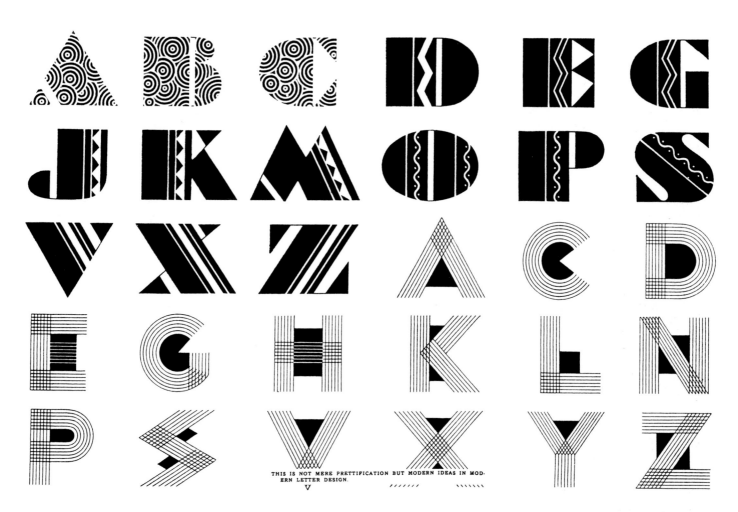

THIS IS NOT MERE PRETTIFICATION BUT MODERN IDEAS IN MODERN LETTER DESIGN.

ALPHABETS

NOVELTY LETTERFORMS, C. 1926–30

DESIGNERS UNKNOWN

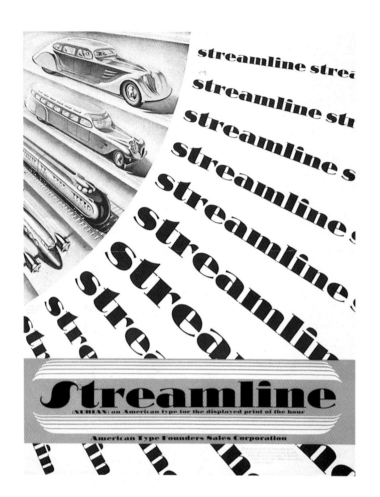

CUBIST BOLD

36 POINT

ABCDEFGHIJ
KLMNOPQRST
UVWXYZ&$
1234567890

30 POINT

READABLE AND

24 POINT

EXOTIC, CUT WITH

20 POINT

AN EYE TO CHARACTER

18 POINT

AND STRENGTH, CUBIST BOLD

14 POINT

AND ITS RICH DECORATIVE MATE-

12 POINT

RIAL OFFER ENDLESS POSSIBILITIES FOR

10 POINT

USE IN DISPLAY LINES, AND MODERN BOOK-COVERS.

HELLER - EDWARDS TYPOGRAPHY, *Inc.* · 209 WEST 38*th* ST., NEW YORK

STREAMLINE

TYPE SPECIMEN SHEET COVER, 1939

DESIGNER UNKNOWN

CUBIST BOLD

TYPE SPECIMEN SHEET, C. 1933

DESIGNER: HELLER EDWARDS TYPOGRAPHY

ABCDE
FGHIJK
LMNOP
QRSTU
VWXYZ
1234567890

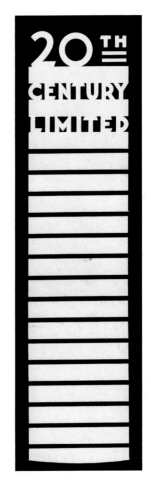

2 0TH CENTURY LIMITED

LOGO, 1938

DESIGNER: HENRY DREYFUSS

ALPHABET

TYPE SPECIMEN, 1937

DESIGNER: BEN HUNT AND ED C. HUNT

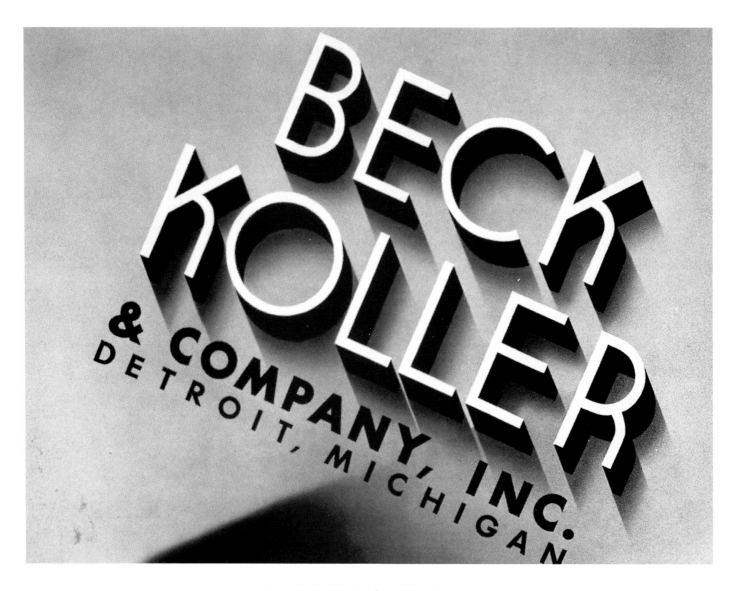

BECK KOLLER & COMPANY

SHADED LETTERFORMS, C. 1938

DESIGNER UNKNOWN

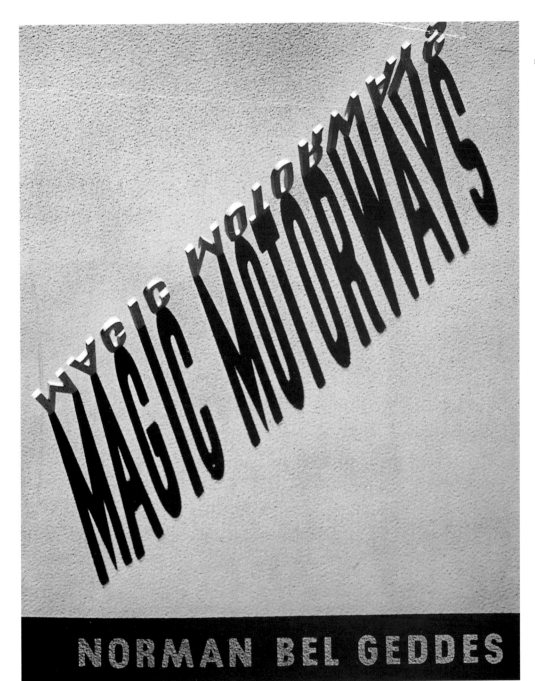

COLOPHON

MAGAZINE/BOOK COVER, 1930

DESIGNER: GUSTAV JENSEN

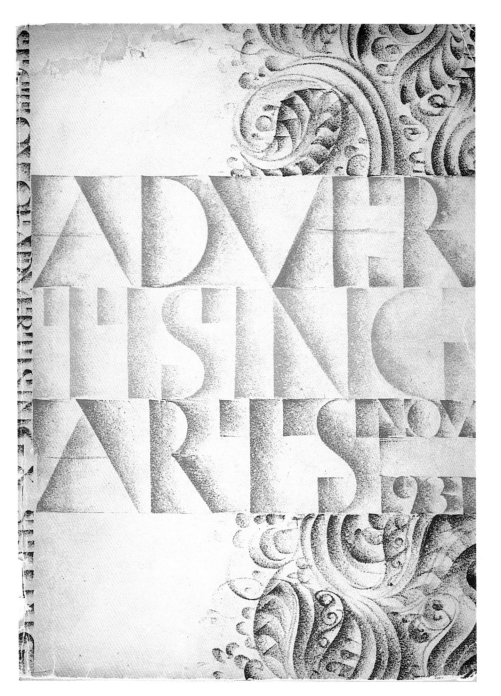

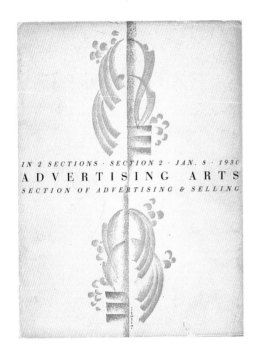

AMERICAN PRINTER

TRADE MAGAZINE COVER, 1929

DESIGNER: GUSTAV JENSEN

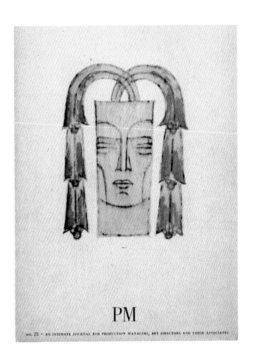

ADVERTISING ARTS

TRADE MAGAZINE COVER, 1930

DESIGNER: GUSTAV JENSEN

PM

TRADE MAGAZINE COVER, 1936

DESIGNER: GUSTAV JENSEN

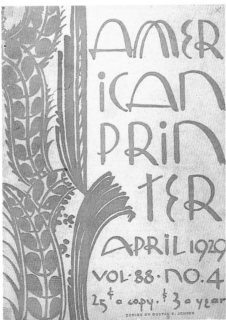

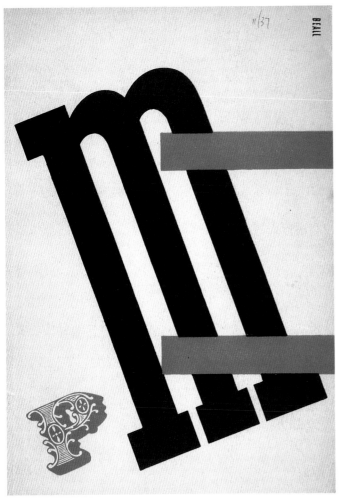

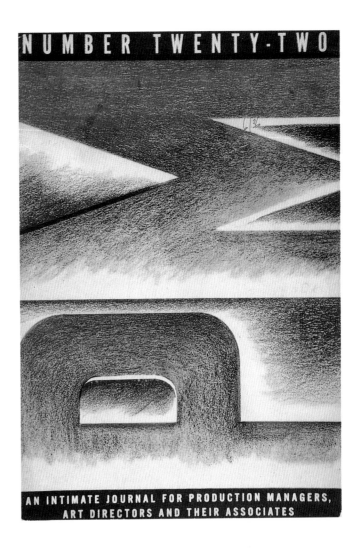

PM

TRADE MAGAZINE COVER, 1937

DESIGNER: LESTER BEALL

PM

TRADE MAGAZINE COVER, 1936

DESIGNER: JOSEPH SINEL

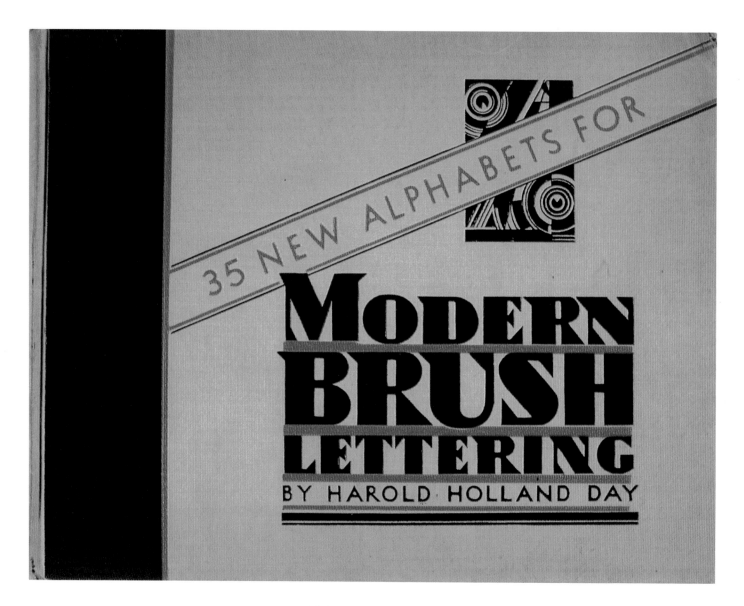

MODERN BRUSH LETTERING

BOOK COVER, 1932

DESIGNER: HAROLD HOLLAND DAY

ABCDEFGHIJ
KLMNOPQRS
TUVWXYZ &
123 456 789

ABCDEFGHIJKLN
MOPQRSTUVWX
YZ

 MISTOGRAPH PATTERNS

MISTOGRAPH PATTERNS

TYPE SPECIMEN, 1932
DESIGNER:
HAROLD HOLLAND DAY

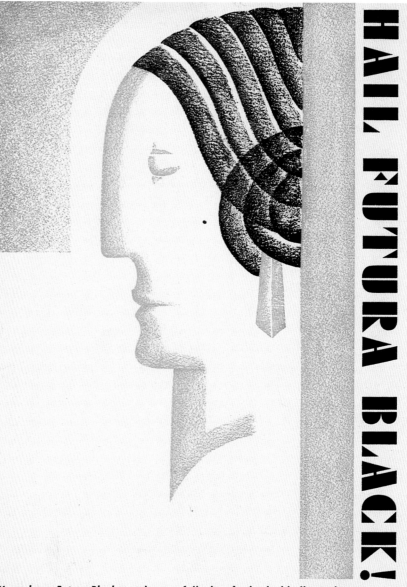

We endorse Futura Black as a letter of display, for its decidedly modern tectonic qualities, for its abstract and geometric design value that lends itself to modern usage as a constructive element of the layout, as an attention-getter and for emphasis. We also recommend its use in connection with color

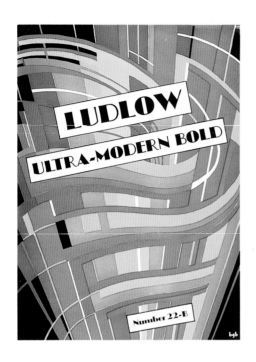

LUDLOW ULTRA-MODERN BOLD

TYPE SPECIMEN SHEET COVER, C. 1933

DESIGNER UNKNOWN

LUDLOW STYGIAN BLACK NO. 25

TYPE SPECIMEN SHEET COVER, C. 1933

DESIGNER UNKNOWN

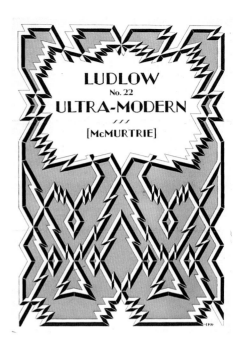

LUDLOW ULTRA-MODERN

TYPE SPECIMEN SHEET COVER, C. 1933

DESIGNER: DOUGLAS C. McMURTRIE

BIBLIOGRAPHY

Arens, Egmont. "Package Engineering." New York: *Advertising Arts*, January 8, 1930.

Bernhard, Lucian. "Lettering and Its Place in Advertising." New York: *Advertising Arts*, January 8, 1930.

_____."Putting Beauty into Industry." New York: *Advertising Arts*, January 30, 1930.

Bush, Donald J. *The Streamlined Decade*. New York: George Braziller, 1975.

Cohen, Barbara, Steven Heller, and Seymour Chwast. *Trylon and Perisphere: The 1939 New York World's Fair*. New York: Harry N. Abrams, 1989.

Calkins, Earnest Elmo. "Art as a Means to an End." New York: *Advertising Arts*, January 8, 1930.

_____. "Advertising Art in the United States." *Modern Publicity*. London: 1930.

Cheney, Sheldon, and Martha Candler Cheney. *Art and the Machine.* New York: Whittlesey House, 1939.

Davies, Karen. *At Home in Manhattan: Modern Decorative Arts 1925 to the Depression*. New Haven: Yale University Art Gallery, 1983.

DeNoon, Christopher. *Posters of the WPA 1935–1945*. Los Angeles: The Wheatley Press, 1987.

Gress, Edmund G. *Fashions in American Typography 1780–1930*. New York: Harper Brothers, 1931.

Heide, Robert, and John Gilman. *Popular Art Deco*. New York: Abbeville Press, 1991.

McMurtrie, Douglas C. *Modern Typography and Layout*. Chicago: Eyncourt Press, 1929.

O'Connor, John, and Lorraine Brown. *The Federal Theatre Project: 'Free, Adult, Uncensored.'* London: Eyre Methuen, 1980.

Young, Frank H. *Modern Advertising Art*. New York: Covici, Friede Inc., 1930.

_____. "Modern Layouts Must Sell Rather Than Startle." New York: *Advertising Arts*, January 8, 1930.